IMAGES
of America

AUBURN'S
FORT HILL CEMETERY

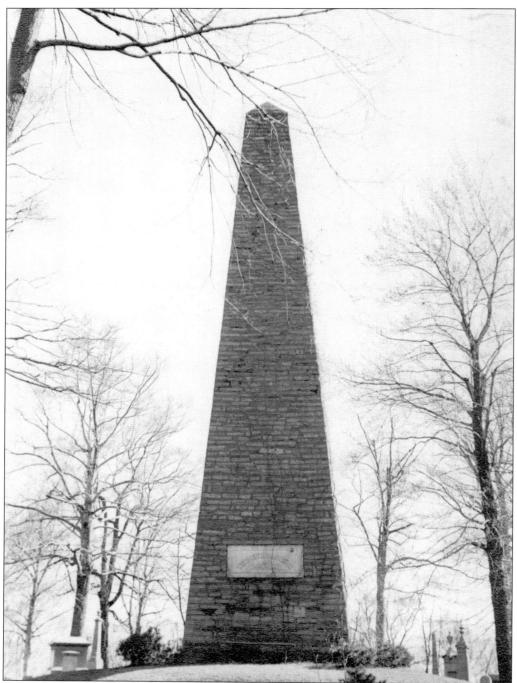

Logan's monument sits atop the center mound of the original native village. It was constructed in 1852–1853 from locally quarried limestone. It is 52 feet high. The plaque on the north side reads, "Who is there to mourn for Logan?" This was the closing line of a speech given by Logan c. 1795, detailing the carnage of the wars between the Native Americans and whites. He answered his own question, saying, "Not one." (Courtesy Fort Hill Cemetery Association.)

Ordered by: Janet Heywood
580 Mount Auburn Street
Mount Auburn Cemetery
Cambridge, MA 02138
UNITED STATES

Ship to: Janet Heywood
580 Mount Auburn Street
Mount Auburn Cemetery
Cambridge, MA 02138
UNITED STATES

PN #	Seller Book I.D.	Alibris I.D.	Title / Author	Order Date
2834141-2	006617	8045921778	Auburn's Fort Hill Cemetery (Images of America Ser. : New York) Rosell, Lydia.	Jul. 16 2002

Condition: As New Soft Cover

Thank you for your order!

Return Instructions

If you are dissatisfied for any reason, return your purchase within 30 days of receipt for a full refund of the purchase price. Please include the Packing Slip and indicate the reason for return for fastest processing. If the return is a result of our error, we will refund your return shipping costs up to $2.95 per item (or for best results, use the postage-paid return label provided by Alibris at http://www.alibris.com/returns).

Reason for Return:
☐ Item not as described
☐ Item different than expected
☐ Incorrect item received
☐ Other

U.S. Returns:
Visit http://www.alibris.com/returns to obtain a postage paid return label

Non-U.S. Returns:
Alibris Distribution Center - Returns
475 Lillard Drive #102
Sparks, NV 89434-8926 USA

Problems? Questions? Suggestions? Send e-mail to Alibris Customer Service at info@alibris.com.

http://sellers.alibris.com/ops/displaypurchaseorder.cfm?Order_Nbr=2834141-2 7/18/2002

IMAGES
of America

AUBURN'S
FORT HILL CEMETERY

Lydia J. Rosell

ARCADIA

First printed in 2001.

Published by Arcadia Publishing,
an imprint of Tempus Publishing, Inc.
2A Cumberland Street
Charleston, SC 29401

Printed in Great Britain.

Library of Congress Catalog Card Number: 2001093043

For all general information contact Arcadia Publishing at:
Telephone 843-853-2070
Fax 843-853-0044
E-Mail sales@arcadiapublishing.com

For customer service and orders:
Toll-Free 1-888-313-2665

Visit us on the internet at http://www.arcadiapublishing.com

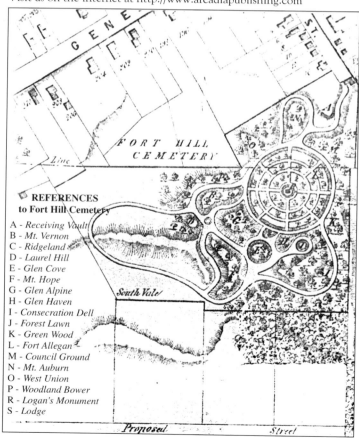

REFERENCES
to Fort Hill Cemetery

A - Receiving Vault
B - Mt. Vernon
C - Ridgeland
D - Laurel Hill
E - Glen Cove
F - Mt. Hope
G - Glen Alpine
H - Glen Haven
I - Consecration Dell
J - Forest Lawn
K - Green Wood
L - Fort Allegan
M - Council Ground
N - Mt. Auburn
O - West Union
P - Woodland Bower
R - Logan's Monument
S - Lodge

This map shows Fort Hill Cemetery c. 1860.

CONTENTS

ACKNOWLEDGMENTS

My deepest gratitude, affection, and respect I give to these people who believed in my vision and gladly gave assistance for its fulfillment: Kathy Walker and the Board of Community Preservation Committee; Don Poole and Elaine Hudson, Fort Hill Cemetery Association; Stephen Erskine and Mary Gilmore, Seymour Library; Peter Wisbey, Paul MacDonald, and Karen Bove, Seward House; Edward Hayes, Cayuga Home for Children; Chris Cummings, Faatz-Crofut Home; Malcolm Goodelle, Cayuga County Historian; Gina Stankivitz, Cayuga Museum; George and Jean Kerstetter; Lou and Myrtle Chomyk; Ward DeWitt and Rev. Paul Carter, Harriet Tubman Home; Jon and Ann Robson, Dan Klink, and Kevin Goodman, Auburn Document Centre; and Pauline Johnson and Judith G. Bryant, descendants of Harriet Tubman's sister and brother, who "do Aunt Harriet proud."

Lastly, I would like to thank Stephanie Przybylek for inspiration and Molly Shea for the music.

Dedicated to the memory of my grandmother, Nina Riley (May 30, 1906–October 30, 1964). We shared our birthday, Memorial Day, communing with the ancestors. She taught me to hear the voice of the muse whispering in the gardens of stone.

INTRODUCTION

Many books have been written about the history of Auburn, New York, chronicling how its citizens lived: they worked, played, celebrated, worshiped, transacted business, and occasionally killed each other. This book explores new territory by looking at how the people of the city memorialized themselves and their families in the fashionable Victorian park cemetery, Fort Hill.

The particular challenge for working with old photograph collections is that the author is entirely dependent on the taste and attitude of people from another era. What did they believe was worth the attention of the camera lens and why? When Fort Hill Cemetery was established in 1851, photography was in its infancy; equipment was expensive, bulky, and sometimes dangerous due to chemicals that they used. The camera as a tool for recording history came of age during the Civil War.

Photography emerged as a commercial commodity during the postwar era. This phenomenon produced the popular parlor entertainment, the stereopticon viewer with photograph cards. The stereo camera used binocular lenses to record double images on film, calculated to reproduce the exact perspective of human vision. When the double images were viewed through the twin lenses of the stereo viewer, the images appeared to be seen in natural three-dimension. It must have been a thrill to peer into the viewer for the first time. An entire industry emerged, mass-producing stereo photographs sold door-to-door in sets depicting domestic and foreign images. Soon, families living in isolated farmsteads could spend leisure hours gazing at exotic scenes in the comfort of their own parlors.

Many of the earlier images in this book of Fort Hill Cemetery were considered equally exotic. Fort Hill went beyond the simple, utilitarian cemetery of the Colonial era. Fort Hill Cemetery was planned as a park, a nature preserve, and a repository of monumental sculpture during the era when mourning was raised to an art form. The images convey a subtle message about what really mattered to the people of the mid-19th century.

Another challenge with this collection was that many of the notable people were still alive and working on making history. There were no contemporary images recorded of their family plots. Others were not even born or were children during the period examined by this book.

Some images were taken to record the ravages of nature or vandalism. Sites change over the years through planned alteration or an increased number of monuments. Some sites in these images have been rendered unrecognizable over time. Special care has been taken to assess the approximate location reflected in those images.

There is a great contrast between the individuality of images of monuments as well as the

foliage in the older sections of the cemetery and the modern images of the carefully groomed plots with stones of uniform size and shape. These depict a paradigm shift over the past century between the age of individualism and an age of collective conformity. The modern plots lend themselves to more efficient care but lose much of the aesthetics of the old sites. Most entertaining are the stories of the people in lives long ended.

One

GATEWAY TO HISTORY

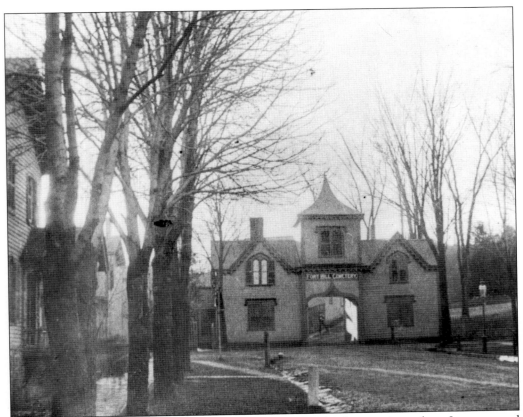

"The Lodge," shown *c.* 1852, was an apartment and office for the superintendent. It was moved to Garrow Street *c.* 1892 to prepare for construction of Bradley Memorial Chapel.

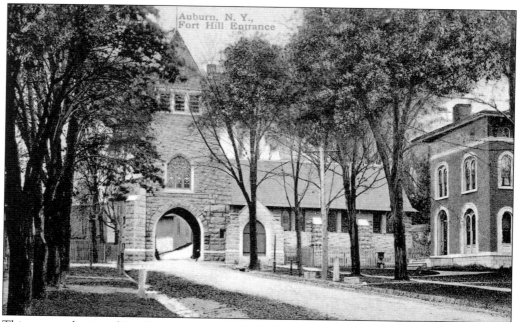

This postcard view of Bradley Memorial Chapel was taken sometime between 1893 and 1928. (Courtesy Lou and Myrtle Chomyk.)

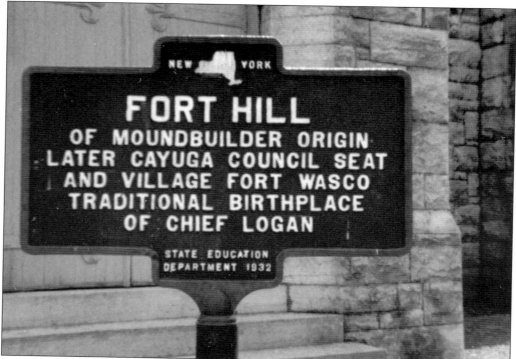

This historic marker was installed in 1932 by the state education department in front of Bradley Memorial Chapel. Its companion sits at the corner of Fort and Genesee Streets. (Courtesy Fort Hill Cemetery Association.)

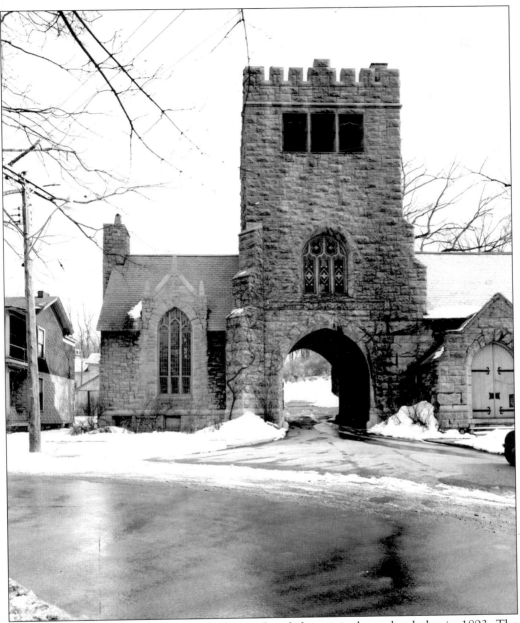

Bradley Memorial Chapel, shown *c.* 1951, replaced the original wooden lodge in 1893. The chapel was a gift of Jane Loomis Bradley as a memorial to her husband, Silas Bradley, president of a local bank. The Gothic Revival building was designed by Julius A. Schweinfurth, the distinguished architect who also created the James Street School and the Osborne home, at 115 South Street. The office section to the left was added in 1928 from a gift from Eliza Wright Osborne. (Courtesy Fort Hill Cemetery Association.)

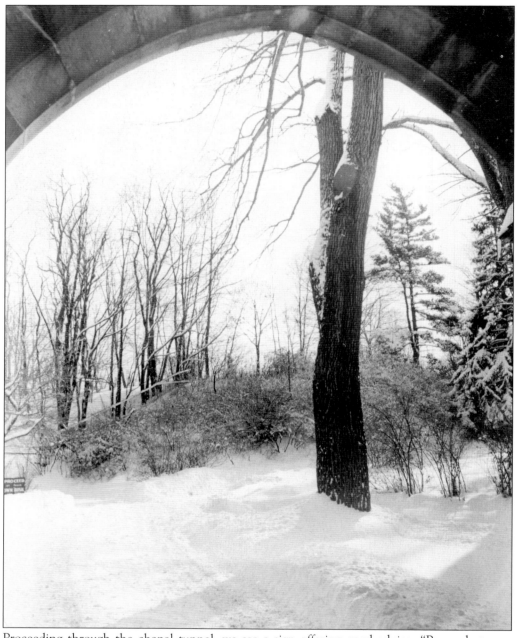

Proceeding through the chapel tunnel, we see a sign offering good advice: "Proceed at own Risk." (Courtesy Fort Hill Cemetery Association.)

In this c. 1940 photograph, a cemetery worker poses between a historic marker and the door to Bradley Chapel to illustrate the depth of a recent snowfall. (Courtesy Fort Hill Cemetery Association.)

This photograph shows the drive through gate at Bradley Chapel after a snowstorm. (Courtesy Fort Hill Cemetery Association.)

A worker guards the gate sometime between 1939 and 1949. (Courtesy Fort Hill Cemetery Association.)

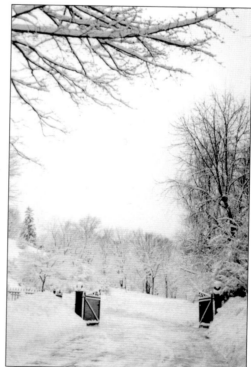

The Fort Street gate opens into a frosted wonderland in this view looking west *c.* 1940. (Courtesy Fort Hill Cemetery Association.)

The northern base of Mount Auburn is
shrouded in a mantle of fresh snow c. 1940.
(Courtesy Fort Hill Cemetery Association.)

The receiving vault and T.J. Kennedy vault
are obscured by the snowstorm. (Courtesy
Fort Hill Cemetery Association.)

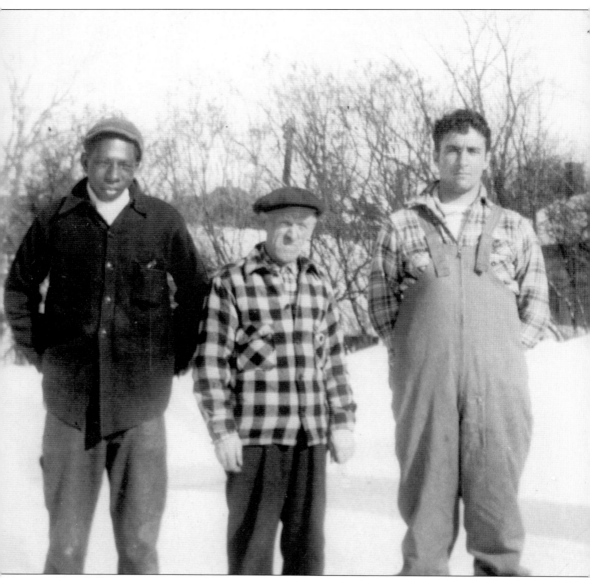

Fort Hill workers pose in this *c.* 1950s photograph. The man in center is possibly William J. Lee, a third Lee generation to superintend operations at the cemetery. (Courtesy Fort Hill Cemetery Association.)

The Bradley family monument appears stranded in the snow. (Courtesy Fort Hill Cemetery Association.)

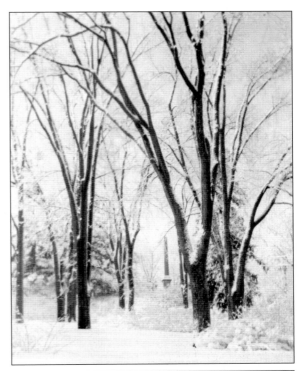

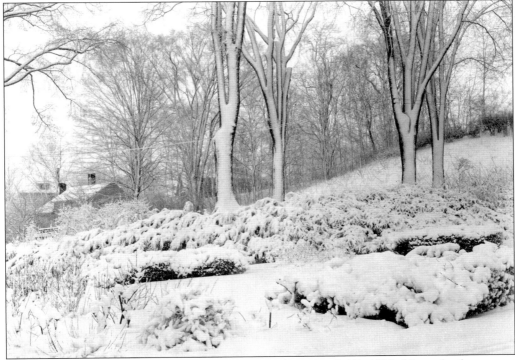

Snow blankets the bushes behind Bradley Chapel on April 17, 1935. Note the houses on Westlake Avenue. (Courtesy Fort Hill Cemetery Association.)

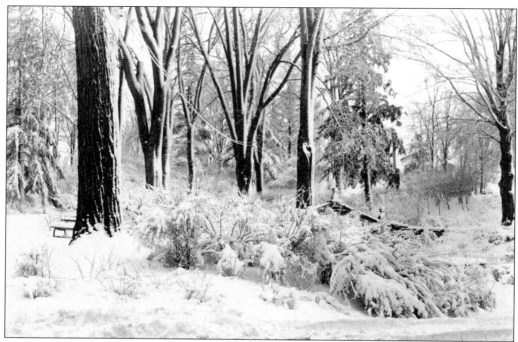

The storm of April 17, 1935, all but obscures the receiving vault behind Bradley Chapel. (Courtesy Fort Hill Cemetery Association.)

This view behind Bradley Chapel is looking south to the receiving vault *c.* 1951. (Courtesy Fort Hill Cemetery Association.)

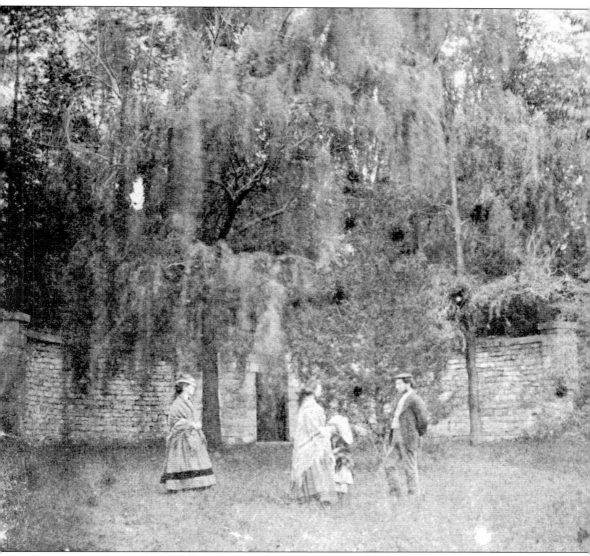

Mourners gather in front of the receiving vault *c.* the 1860s. (Courtesy Seymour Library.)

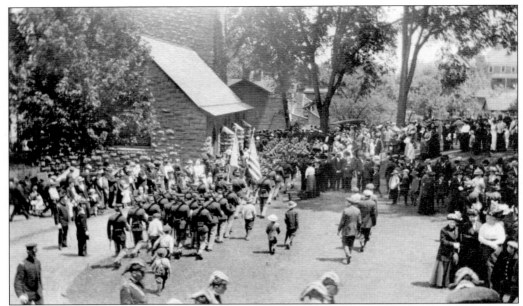

Soldiers, Masons, and a well-dressed public participate in Memorial Day services behind Bradley Chapel on May 30, 1914. In a few days, Archduke Ferdinand of Austria will be assassinated and plunge Europe into "the war to end all wars." These veterans of the Civil War and Spanish-American War are celebrating patriotic fervor of wars long past and do not yet know what the near future holds. (Courtesy Community Preservation Committee.)

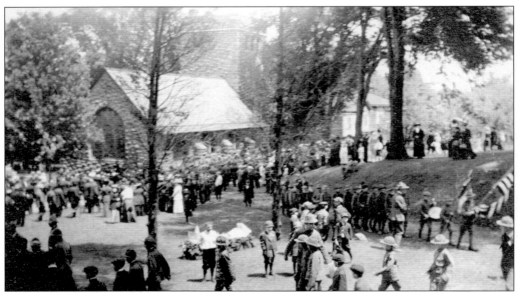

On May 30, 1914, behind Bradley Chapel, soldiers perform memorial rites. In the foreground on the left, a contingent honors Terrence J. Kennedy, who raised (at his own expense) the first regiment in Cayuga County to enter service in the Civil War. (Courtesy Community Preservation Committee.)

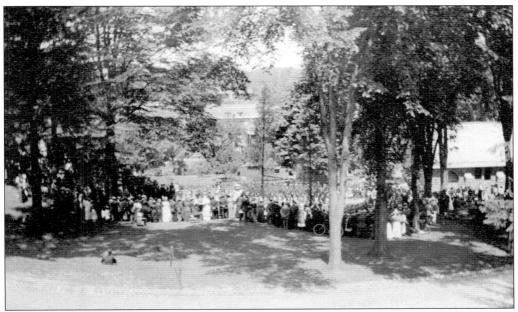

Here a photographer aims his lens over the top of the receiving vault to capture the crowd behind Bradley Chapel on May 30, 1914. (Courtesy Community Preservation Committee.)

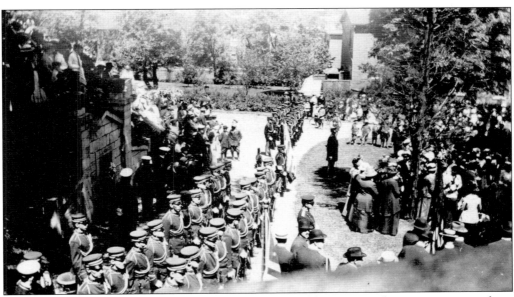

This is a postcard view of a military ceremony c. 1890. Soldiers are standing at attention in front of the T.J. Kennedy vault. There is no exact date indicated on the card. It could be Memorial Day, a VIP funeral, or some other important event. (Courtesy Lou and Myrtle Chomyk.)

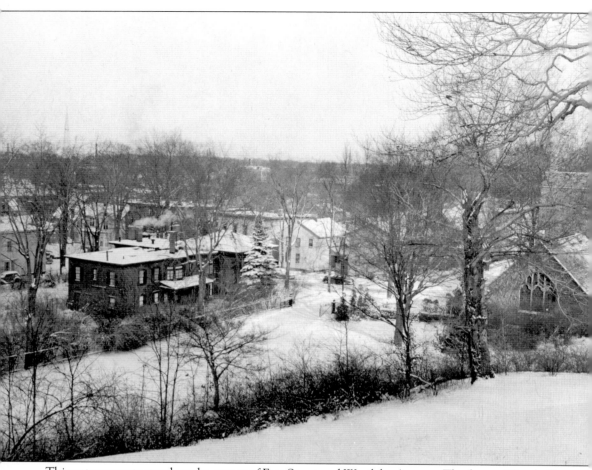

This entrance gate stands at the corner of Fort Street and Westlake Avenue. The former Woodruff home is to the left and Bradley Chapel is to the right. (Courtesy Fort Hill Cemetery Association.)

Two

WAR AND FLU
ACCELERATE BURIALS

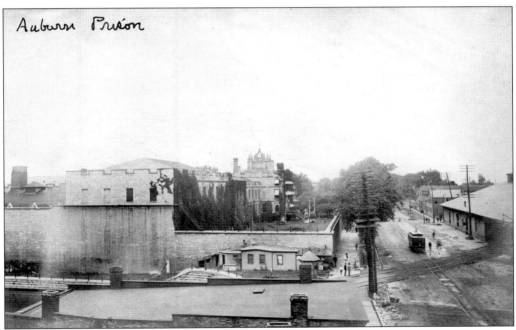

Auburn Prison, on State Street, is shown c. 1914. The New York Central train station is across the street to the right. Soldiers embarked from this station to enter military service in World War I. Many who survived the war died from the Spanish influenza epidemic. (Courtesy George Kerstetter.)

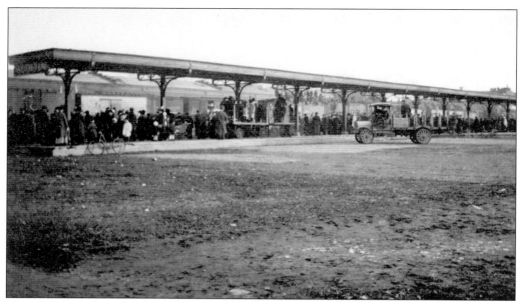

Crowds gathered at the New York Central train station on State Street to bid farewell to soldiers leaving for the war in Europe. Note the lone truck in the lot, a vehicle from a local delivery company. (Courtesy Community Preservation Committee.)

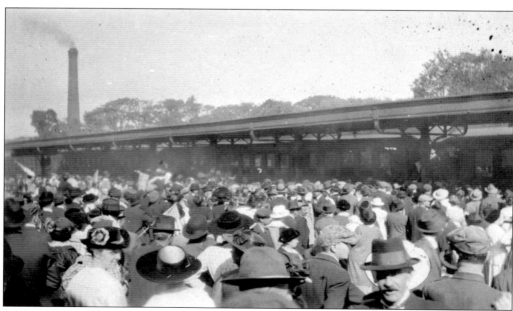

Smiling faces under fashionable hats suggest the patriotic enthusiasm for the departing soldiers on the train. The faces express the glory of the war with none of its horror yet to come. (Courtesy Community Preservation Committee.)

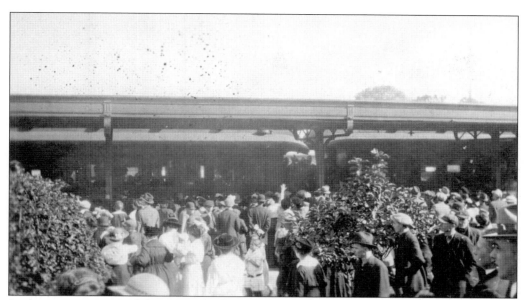

In the passenger cars of the train, the faces of the soldiers are obscured by the shadows. It is impossible to know who will die horrible new deaths from war and impending plague of the Spanish influenza. (Courtesy Community Preservation Committee.)

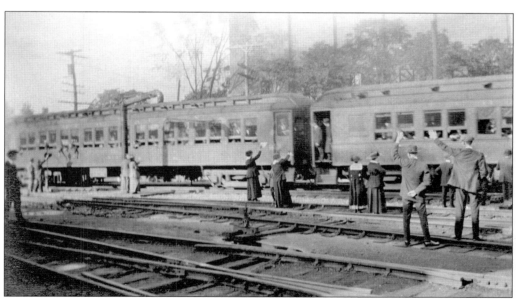

The crowd is sparser past the boarding platform, but their enthusiasm is not diminished. Everyone is now waving farewell to loved ones leaving to face an uncertain future. (Courtesy Community Preservation Committee.)

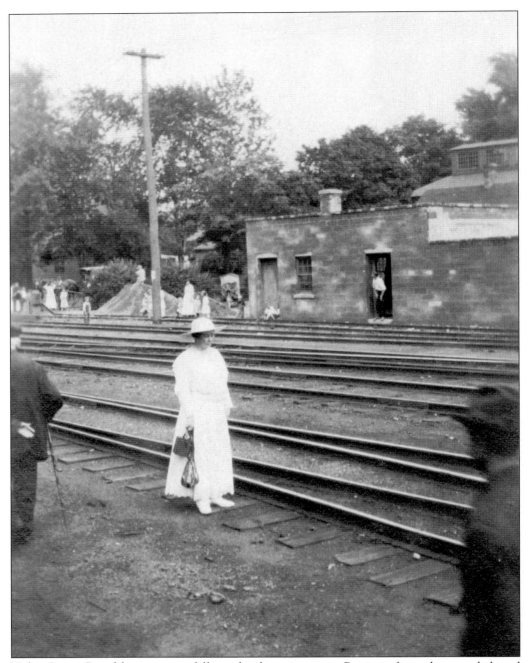

Helen Porter Beardsley gazes wistfully at the departing train. Patriotic fervor has receded, and her face bears an expression of being about to burst in prayer, tears, or both. She seems resigned to what the future holds but apprehensive that it will not be good. (Courtesy Community Preservation Committee.)

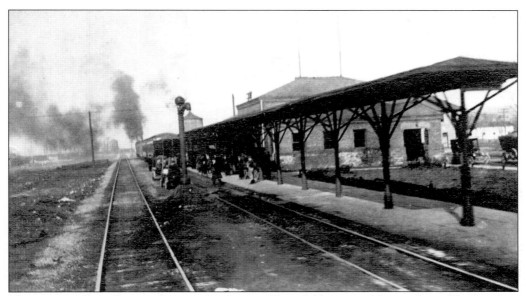

The train finally pulls away, leaving the throng of hopeful hearts and loving faces. The receding train leaving empty tracks and a vacant platform looks lonely already and somehow ominous. (Courtesy Community Preservation Committee.)

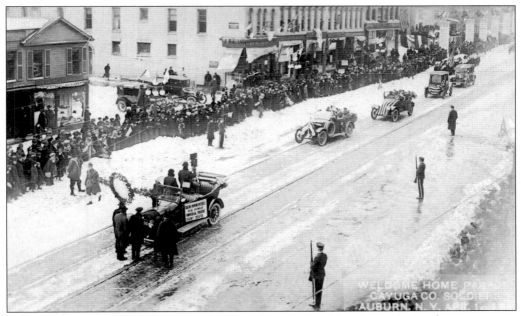

Auburn welcomes its soldiers returning from World War I in Europe. Note the cameraman standing in the back of the convertible car. The sign on the door reads, "Taking moving pictures to be shown at the Universal Theater and Regent Theater." Even as this scene progressed, Theodore W. Case was busy in his laboratory behind the former Willard Mansion, developing the tools to make the moving pictures talk. (Courtesy Seymour Library.)

The war to end all wars didn't. In this picture taken on Memorial Day 1943, patriotic fervor is once again generated by crowds of soldiers and civilians behind Bradley Chapel. (Courtesy Fort Hill Cemetery Association.)

Three

SHAPING ROADS,
SHAPING HISTORY

An unpaved Cayuga Avenue winds upward around the border of the hill above the receiving vault *c.* 1951. (Courtesy Fort Hill Cemetery Association.)

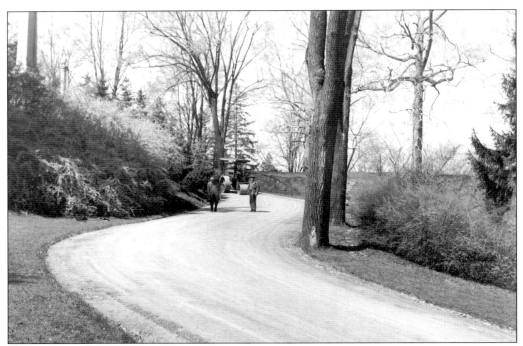

Workers pause to the left of Mount Auburn to plan the next move for paving Cayuga Avenue *c.* 1951. (Courtesy Fort Hill Cemetery Association.)

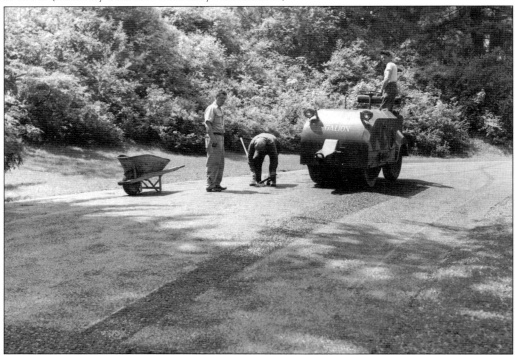

These unidentified workers are laying the pavement on Cayuga Avenue *c.* 1951. (Courtesy Fort Hill Cemetery Association.)

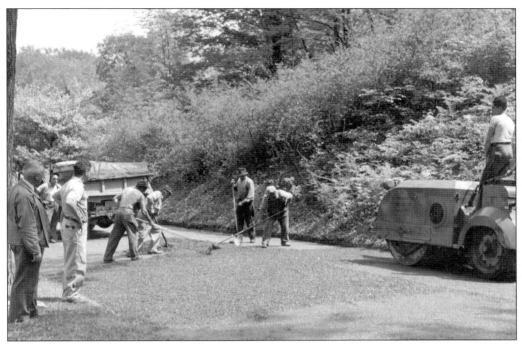

The crew puts final additions on the pavement of Cayuga Avenue *c.* 1951. (Courtesy Fort Hill Cemetery Association.)

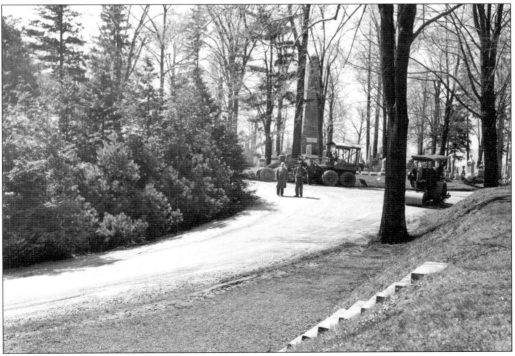

The paving project resumes with the steps leading up to the crest of Mount Auburn *c.* 1951. (Courtesy Fort Hill Cemetery Association.)

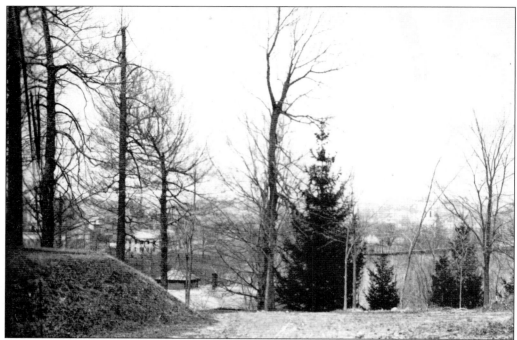

This view was taken looking north from the east side of Mount Auburn. The roof of the Woodruff home is just visible in the center. (Courtesy Seymour Library.)

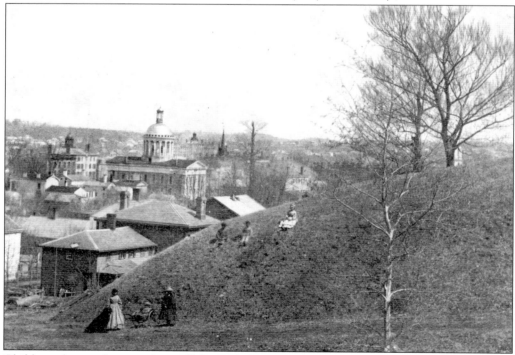

Children play on the west slope of Mount Auburn. Looking east over the roof of the Woodruff house, the view of the domed courthouse is clear. (Courtesy Seymour Library.)

This plaque, dedicated to the career of Harriet Tubman, was installed beside the entrance of the Cayuga County Courthouse in 1914. (Courtesy Cayuga Museum.)

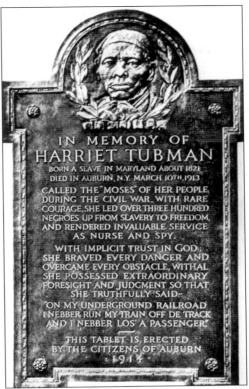

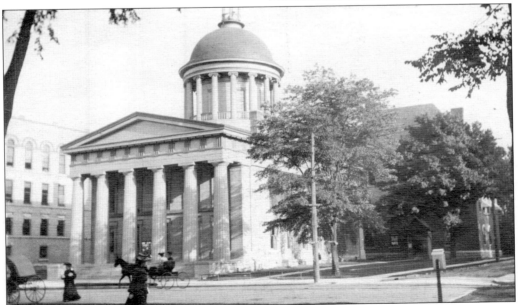

The Cayuga County Courthouse, located on the corner of Genesee and State Streets, is shown c. 1900. The dome was destroyed by fire in 1922. Bronze memorial plaques honoring William H. Seward and Harriet Tubman are displayed on each side of the front entrance. (Courtesy George Kerstetter.)

A barrier prohibits traffic from interfering with the paving project *c.* 1951. (Courtesy Fort Hill Cemetery Association.)

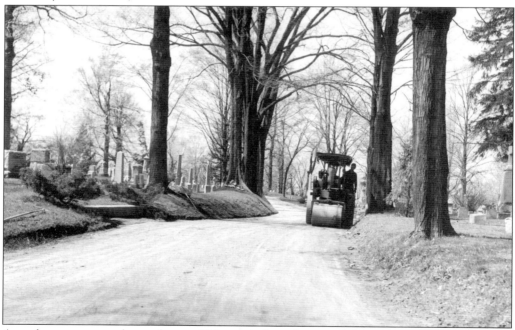

A workman prepares the road west of Mount Auburn for paving. Note the embankment to the left of the road. This was part of the original Mound Builders' fortification of their village. The monument with the cross at the right is the burial site of Thomas Y. How. How and George W. Hatch were two of the original owners of Fort Hill. (Courtesy Fort Hill Cemetery Association.)

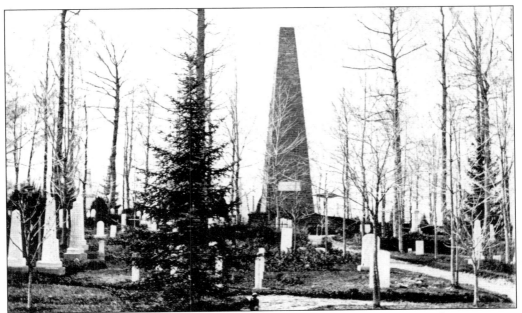

This early view of Logan's monument shows an unpaved road, a clear path to the monument with a directional sign, and an array of trees in various stages of growth. Few of those now exist. The mounds in the foreground define the northern border of the original Mound Builder village. (Courtesy Seymour Library.)

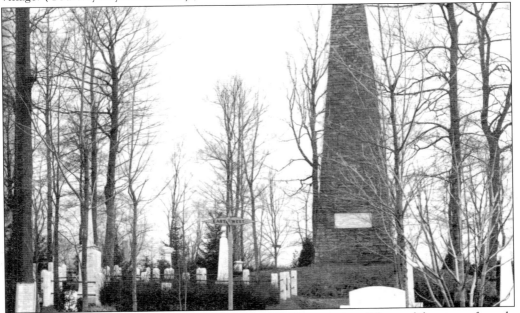

Logan's monument is in the heart of the Fort Alleghan section. The proliferation of newly minted gravestones would render this site alien to the eyes of the Mound Builders or Cayuga nation. The alterations over time have made this image just as alien to our vision: the path is now covered with grass, the fences are all gone, stones have weathered, and many trees have fallen to storms or decay. (Courtesy Seward House.)

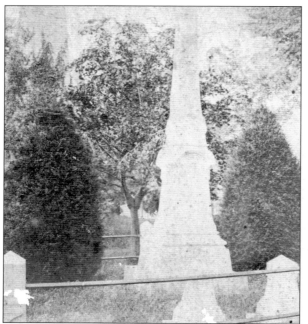

Robert Riley was born in 1818 in Staffordshire, England, and raised at Wolvert Hampton. As a young man, he joined a band of Gypsies and learned the craft of horse trading. He married the sister of Elijah Cooper, who is buried in the Gypsy plot (the first plot on the left of the path leading to Logan's monument). Riley died in Buffalo, New York, on September 22, 1893, and was brought to Auburn to be held in the receiving vault until the spring of 1894. His son purchased the lot, south of Logan's monument, and stones for $1,500, half the original price. The lot and stone were the former property of the Willard-Case family. Riley is the great-great-great-great-grandfather of the author. (Courtesy Seymour Library.)

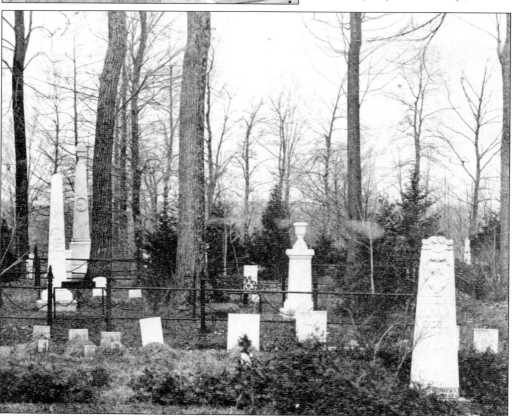

This view is directed south from behind Logan's monument. (Courtesy Seymour Library.)

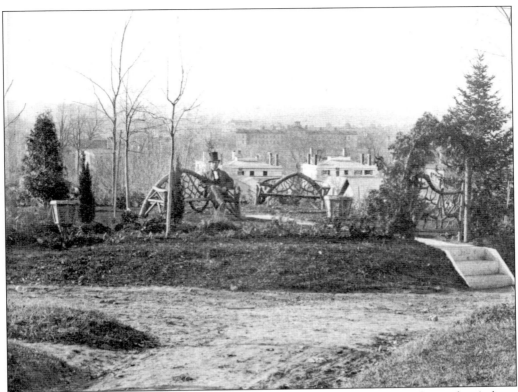

Facing north from the path emerging from Logan's monument, this view shows the Auburn Prison in the background. The stone steps, the rustic furniture, and the man in the stovepipe hat are all gone, and the site now barely resembles this photograph. (Courtesy Seward House.)

Shown here is Mount Auburn, Fort Hill Cemetery, as seen from the newly emerging Woodlawn Avenue, south of Genesee Street. (Courtesy Community Preservation Committee.)

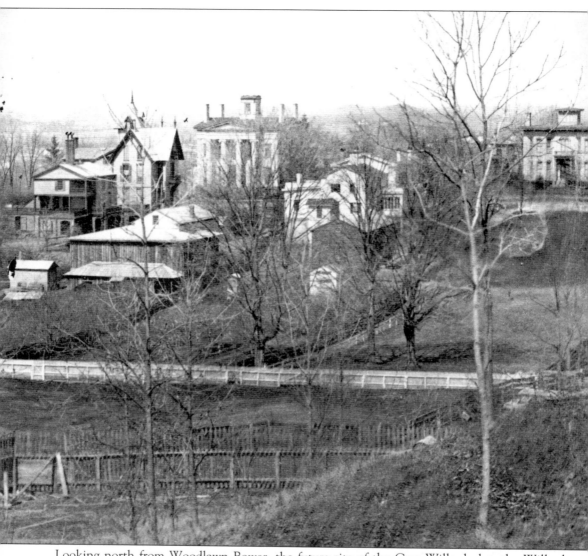

Looking north from Woodlawn Bower, the future site of the Case-Willard plot, the Willard mansion rises in the background left of center. The residence of Abijah Fitch is to the right. The white fence running horizontally across the center marks the future Woodlawn Avenue. (Courtesy Seward House.)

Four
CASE-WILLARD DYNASTY

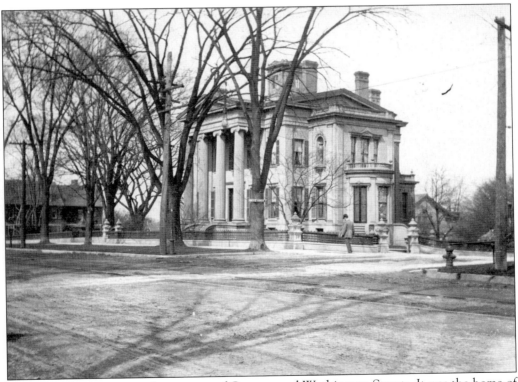

The Willard mansion stands at corner of Genesee and Washington Streets. It was the home of Dr. Sylvester Willard, his wife, Jane, and daughters Caroline and Georgianna. From 1916 to 1936, this was the Case Research Laboratory. It became the Cayuga Museum in 1936. (Courtesy George Kerstetter.)

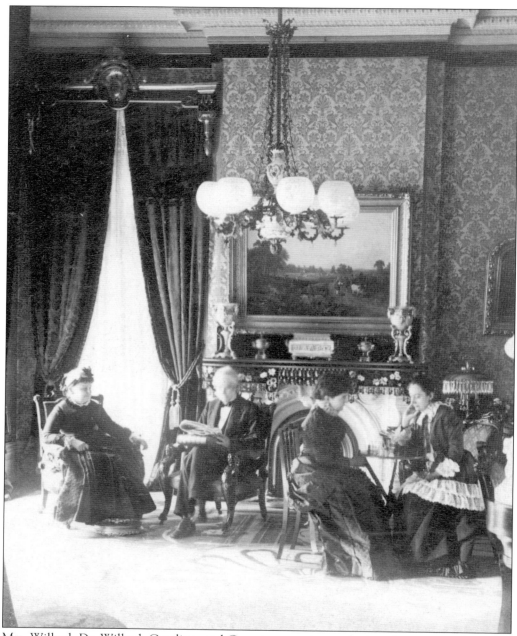

Mrs. Willard, Dr. Willard, Caroline, and Georgianna enjoy a relaxing afternoon in the parlor of their mansion at 203 Genesee Street. (Courtesy Seymour Library.)

Dr. Sylvester Willard lived in Auburn from 1843 to 1886. He was president of the Oswego Starch Company and was involved with a multitude of other business interests. As a public philanthropist, he supported the YMCA, the Elmira Women's College, the Auburn Seminary, and other church-related institutions. Privately, he financially assisted students, alleviated emergencies of the poor, and worked to reform prostitutes. A complex man of firm convictions, he often forgave debts. Just as often, he gave harsh opinions about people who failed to meet his standards. For example, he vehemently despised Brigham Young as "a libertine." Whether he spent tens of thousands of dollars for investments or 30¢ for cabbages, he kept a journal recording every cent he handled. Willard died on March 12, 1886. (Courtesy Community Preservation Committee.)

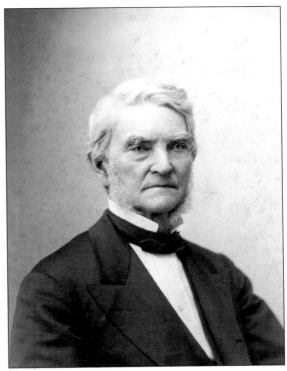

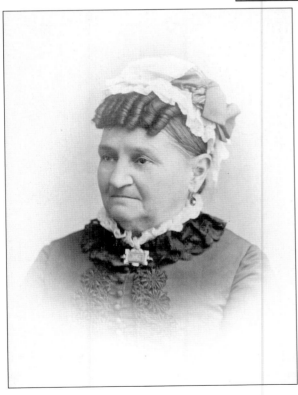

Shown is Jane Case Willard, wife of Dr. Sylvester Willard and mother of Caroline and Georgianna. She was the sister of Theodore P. Case. She died on July 9, 1890. (Courtesy Cayuga Museum.)

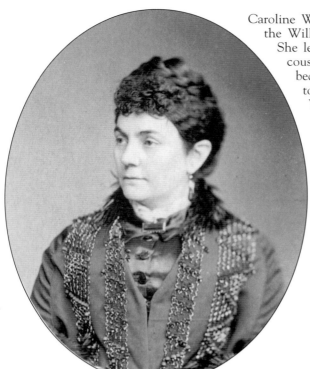

Caroline Willard, the last surviving member of the Willard family, died on March 1, 1916. She left her property to Willard Case, her cousin. When Caroline died, she bequeathed her fortune of $1.8 million to various institutions, including the YMCA, Elmira Women's College, and various church and missionary organizations. She left a gift of $400 to Anna McComb, her housekeeper of 40 years. Caroline, along with her sister Georgianna, donated $50,000 in 1892 to build the Willard Memorial Chapel at Auburn Theological Seminary in memory of their parents. (Courtesy Cayuga Museum.)

Georgianna Willard suffered ill health all her life. Although defined as an invalid by her family, she was regarded by her father as a joy and delight. It pained Dr. Willard terribly that, as a physician, he was unable to neither diagnose nor cure his beloved daughter. She died on September 21, 1901. (Courtesy Cayuga Museum.)

Theodore Pettibone Case was the brother of Mrs. Sylvester Willard. His wife was the daughter of industrialist Abijah Fitch. His son Willard E. Case donated the building in his name, housing the Seymour Library, in 1901. Theodore Case died on May 12, 1891. (Courtesy Community Preservation Committee.)

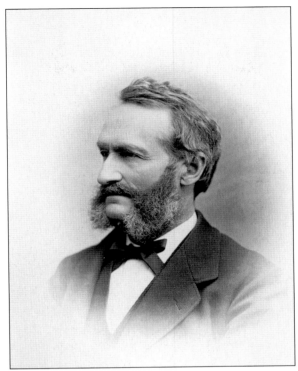

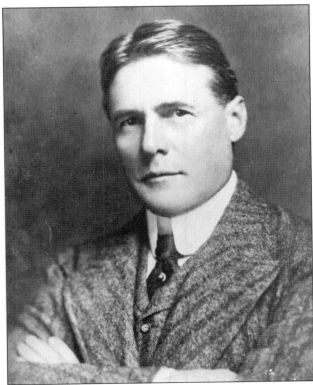

Willard E. Case, son of Theodore P. Case, inherited the Willard Mansion in 1916. He and his son Theodore W. Case created the Case Research Lab in the former greenhouse in the back. Willard Case died on October 27, 1918, of the Spanish influenza, just a few weeks before his son's wedding. (Courtesy Cayuga Museum.)

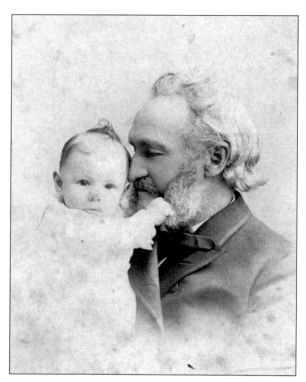

Theodore P. Case and his new grandson, Theodore Willard Case, are seen here in 1889. The baby was born on December 12, 1888, and would later invent a new technology that would change the world. (Courtesy Cayuga Museum.)

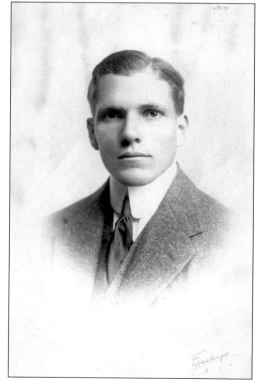

Theodore W. Case is shown c. 1910. Case's invention of the soundtrack for motion picture film revolutionized an entire industry. Furthermore, it made vaudeville obsolete and displaced jobs for thousands of musicians. It did, however, create millions more jobs with skills unimagined before 1926 when he sold his invention for $1 million to the Fox Corporation in New York. Case donated the former Willard mansion in 1936 to house the Cayuga Museum of History and Art. The affable Case never tried to claim fame for his work and died in relative obscurity on May 13, 1944, at only 55 years of age. (Courtesy Cayuga Museum.)

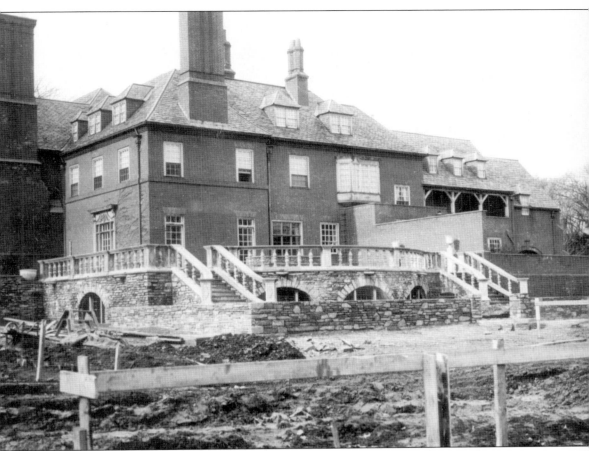

Shown here is the new Case mansion, located on 108 South Street. Theodore W. Case spent $500,000 to build this 60-room Tudor Revival mansion in 1929. It was the site of the former mansion of Gen. Clinton D. MacDougall, Civil War hero and partner of William H. Seward II in the banking business. After living in the mansion for about three years, Case gave the property to the city of Auburn following a dispute over taxes. It was the middle of the Great Depression and no one wanted such a property. The building now houses Unity House, a transitional residence for adults with disabilities. (Courtesy Cayuga Museum.)

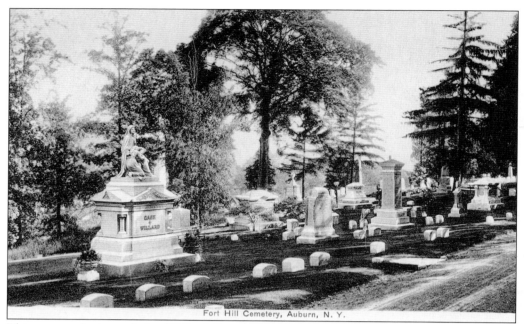

Fort Hill Cemetery, Auburn, N. Y.

This postcard view of the Willard-Case monument faces northeast. (Courtesy Lou and Myrtle Chomyk.)

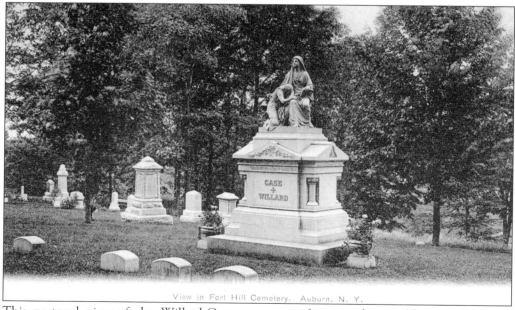

View in Fort Hill Cemetery. Auburn, N. Y.

This postcard view of the Willard-Case monument faces northwest. (Courtesy Lou and Myrtle Chomyk.)

46

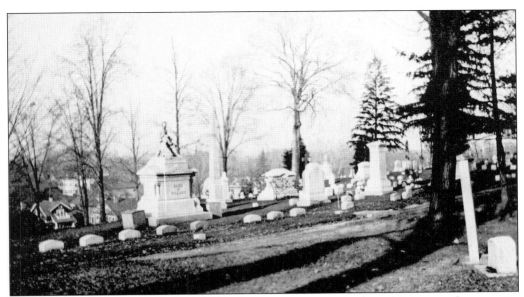

Shown here is the Willard-Case family monument and plot. (Courtesy Community Preservation Committee.)

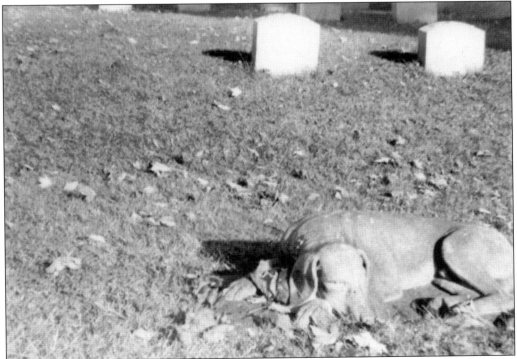

This stone dog statue is across the road from the Willard-Case plot. Dr. Arthur Kennedy was killed in a hunting accident on August 8, 1897. His dog Sport followed the horse-drawn hearse to the gravesite and refused to leave his master. Fearing the dog would starve, the cemetery staff cared for the little animal until it died. They had placed on the grave this monument inscribed "Faithful Friend" to honor his fidelity. (Courtesy author's collection.)

This section west of Fort Alleghan, past the dog statue, runs from the Fitch family plot in the lower left of the photograph, to the Moses family plot in the upper right. The stones on the horizon, to the left and behind the trees, are the lots designated for the Auburn Theological Seminary. Note the slant of the benches in the foreground. How could they possibly be comfortable? (Courtesy Cayuga County Historian.)

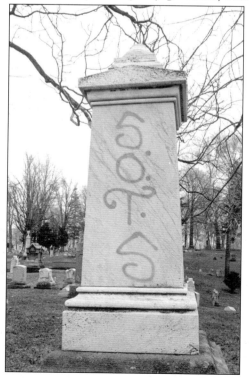

This stone is in the section south of the stone dog. The monument has been spray-painted "SOTS," the logo of a local cult devoted to cemetery vandalism. Despite popular belief, vandalism is not symptomatic of our modern society. Newspaper accounts as early as 1860 complained of wanton destruction of monuments in Fort Hill, offering severe financial penalties for miscreants. (Courtesy author's collection.)

Five

LANE OF A DIFFERENT MEMORY

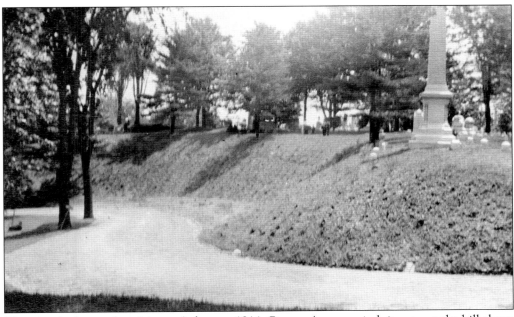

This view looks east from Mount Auburn c. 1914. Cayuga Avenue winds its way up the hill above the receiving vault to emerge at the base of the hill behind the Grosvenor and Humphrey plots at the western border of Council Ground section. (Courtesy Community Preservation Committee.)

The western border of Council Ground section at Cayuga Avenue is shown here *c.* 1951. The road continues clockwise around the perimeter of Fort Allgehan. (Courtesy Fort Hill Cemetery Association.)

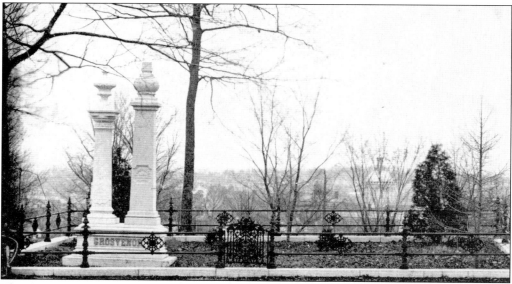

The Grosvenor family plot is east of Mount Auburn. Note the courthouse dome behind the trees. Godfrey Grosvenor died on January 4, 1860, and his wife, Deborah, died on April 13, 1860. The very different styles of stones sharing the same base suggest they were both rugged individualists with their own sense of style. The Grosvenors lived into their eighties, but four members of their family died on May 30, 1860, according to cemetery records. The iron gate, the fence, and stone base are all gone, and the Humphrey family plot encroaches into that of their in-laws, the Grosvenors. (Courtesy Seymour Library.)

The Humphrey lot, a family of physicians, adjoins the Grosvenor lot to the east. The number of Humphrey stones now outnumbers those of the Grosvenors, with an array of sizes and styles. (Courtesy Seymour Library.)

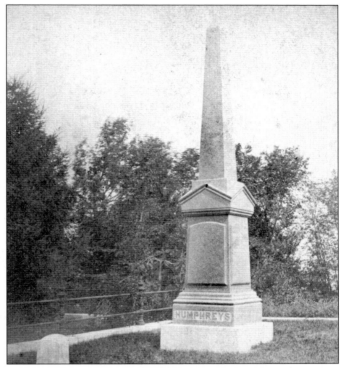

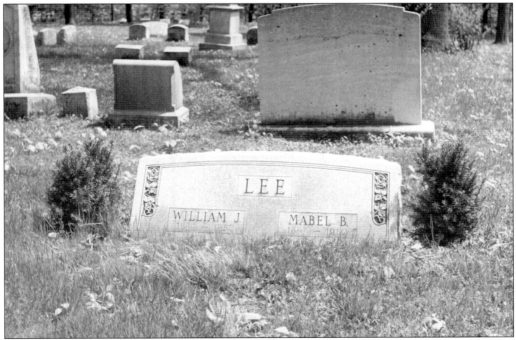

Three generations of Lee men were Fort Hill superintendents: John Lee, from 1869 to 1905; Jacob O. Lee, from 1905 to 1935; and William J. Lee, from 1935 to 1960. All of them are buried in the Council Ground section. (Courtesy Fort Hill Cemetery Association.)

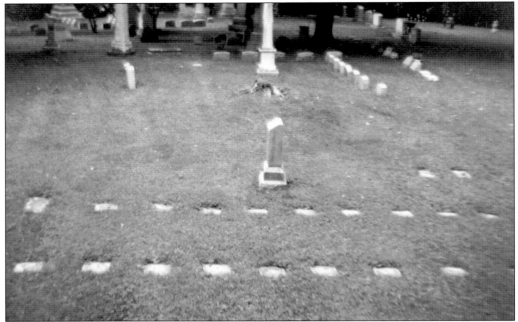

This burial plot was assigned to the Cayuga Asylum for Destitute Children. There were 59 children buried in this lot between 1860 and 1920. The stone in the center is the monument for Jane C. Rogers, superintendent at the orphanage for 32 years until her death on January 18, 1892. (Courtesy author's collection.)

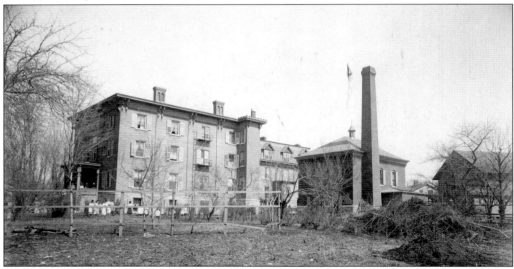

The Cayuga Asylum for Destitute Children was established in 1852 to meet the growing social phenomenon of orphaned and abandoned children. The original wood-frame house on James Street was soon outgrown, and this brick structure was erected at 66 Owasco Street in 1854. It was a constant struggle to raise sufficient money to feed, clothe, and obtain medical treatment for the children. Childhood diseases spread among the population due to exposure in the dormitories, and children occasionally died from diphtheria, whooping cough, or other communicable ailments. (Courtesy Cayuga Home for Children.)

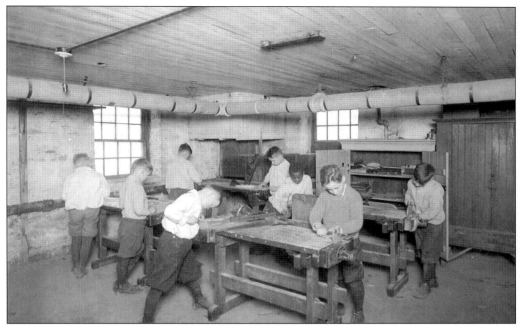

Young boys were taught the value of work and the skills needed to pursue self-sufficiency. These young men are learning a craft in the basement workshop at the orphanage. (Courtesy Cayuga Home for Children.)

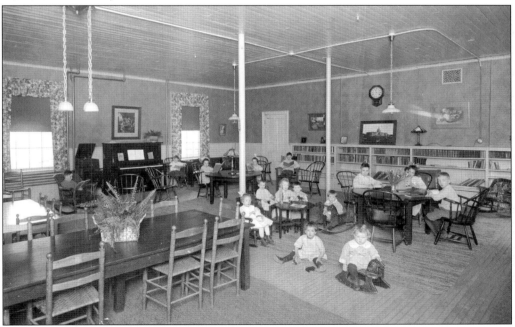

The community room taught social skills as well as work ethics. This room has a library, piano, and Victrola as well as games and toys to occupy their leisure time. These boys and girls seem to have formed their own sense of family and community, mutual support, and companionship. (Courtesy Cayuga Home for Children.)

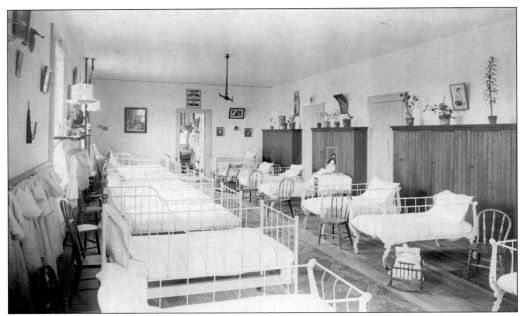

This photograph shows an early dormitory in the Cayuga Asylum for Destitute Children at 66 Owasco Street. The arrangement of the room reflects the philosophy of the institution—rigid discipline grounded in religious principles. The religious motto on the sign over the door promises love as a reward for the acceptance of Christ. This was a powerful tool for managing dispossessed children deprived of family ties. (Courtesy Cayuga Home for Children.)

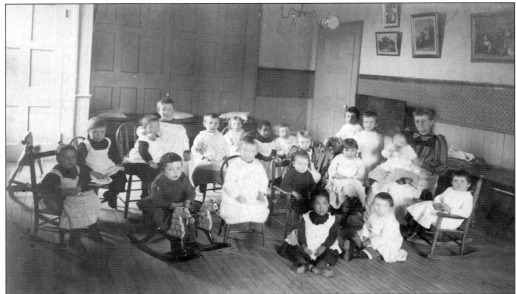

Matrons such as this sweet woman served as surrogate mothers for children of all races and sexes. One such matron, Jane C. Rogers, gave 32 years of her life to the children of the asylum, sacrificing her own "civilian" life. She died on January 17, 1892, and is buried with 59 children in the orphanage plot in the Council Ground section of the cemetery. (Courtesy Cayuga Home for Children.)

Two stylish young men pause atop a mound on the east side of Fort Alleghan. They seem to ponder the fate of Amos T. Walley, who died on August 4, 1868, at the age of 46. (Courtesy Seymour Library.)

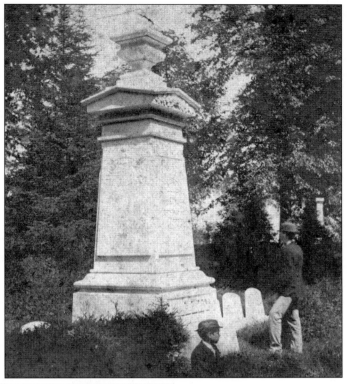

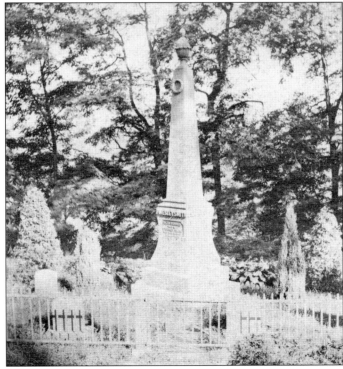

J. Wesley Smith died in Albany on Halloween 1885. He is buried in the Greenwood section. The fence and the abundant ornamental bushes exist now only in this image. A variety of plants on the family plot gave mourners a therapeutic sense of purpose: tend the plants while processing grief. (Courtesy Seymour Library.)

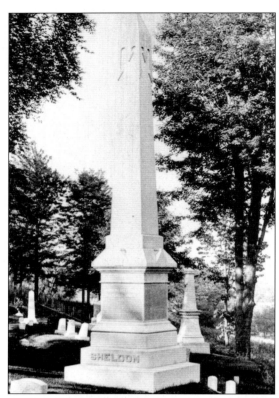

The Sheldon monument is to the left, or east, of the road bordering Fort Alleghan. (Courtesy Cayuga County Historian.)

This road is the southern approach, east side, to Logan's monument in Fort Alleghan. Note the ornate McMaster monument to the left of the center. (Courtesy Cayuga County Historian.)

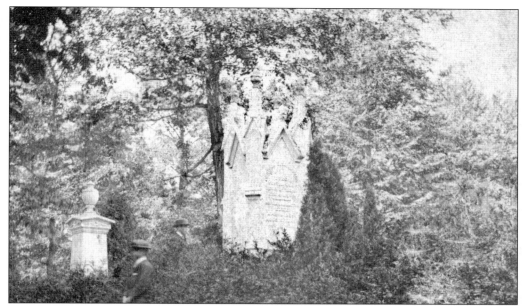

This dapper man poses beside the McMaster monument, perhaps pondering the military careers of the McMaster men in the Civil War. The dense shrubbery obscures the large mounds of the southern boundary of Fort Alleghan. Logan's monument is behind the trees. (Courtesy Seymour Library.)

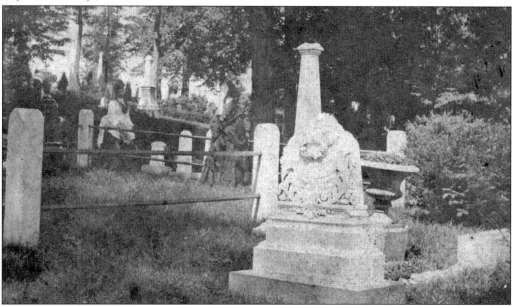

Three stylish women in mourning tend to the duties of their status in their family lot adjoining the Raeish plot. The fence no longer separates them from Augusta, Edith, and Ophelia Raeish, who died on January 19, 1845; November 4, 1854; and August 31, 1919, respectively. Augusta, who had been buried elsewhere, had been moved to Fort Hill to keep the family together. Several stones throughout the cemetery bear dates of death preceding 1851, when the Fort Hill was established. They were all moved from other locations. (Courtesy Seymour Library.)

The Lawlor family plot is in the Forest Lawn section on the east side. Robert J. Lawlor died on January 17, 1862, at 37. (Courtesy Seymour Library.)

This is Victorian mourning at its most stylish: a rustic bench, ornate urn, and scroll-shaped stone invite the mourner to visit. The monument in the background marks the lot of John Chedell, a merchant and real estate developer who died on March 11, 1875. The stone border on the right defines the Osborne plot: industrialist David M. Osborne; his wife, Eliza Wright Osborne, philanthropist; her mother, Martha Coffin Wright, women's rights activist; and David and Eliza's son Thomas Mott Osborne, prison reformer, author, and politician. Martha Coffin Wright was Lucretia Mott's sister. Many generations of Osbornes have contributed generously to the community and continue to so do. (Courtesy Cayuga Museum.)

Six

THE FAY WAY

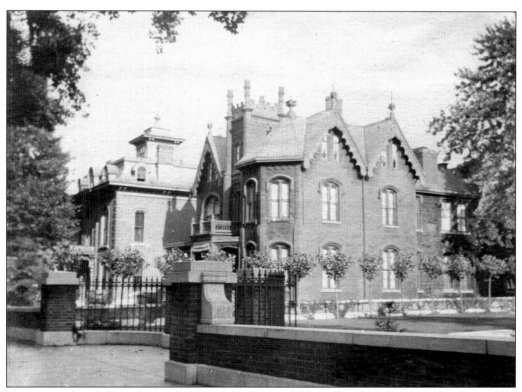

Shown are the Hollister house (left) and the home of Edwin Fay, founder of Fay Bank in 1893. The site of the Hollister house is now a parking lot, and the Fay home is an apartment house. (Courtesy George Kerstetter.)

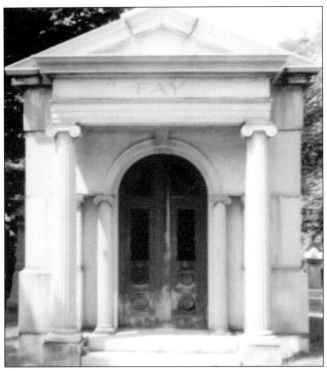

The Fay family mausoleum, completed in October 1907, is the only above-ground crypt in Fort Hill. It measures 18 by 24 feet and is made of Barre granite. The interior is finished with Italian marble. The stained-glass window in the rear, or west end, was designed after a German painting. It was repaired after vandals broke it and is now above the entrance of the Cayuga Museum. One of the 10 catacombs remains eternally vacant. Flora Ward Fay flatly refused to be interred with her husband, Fred. "It was enough I spent my life with that son-of-a-bitch," she was quoted by a contemporary, "I'll be damned if I'll spend eternity next to him!" She is buried with her son at the western base of Mount Auburn. (Courtesy author's collection.)

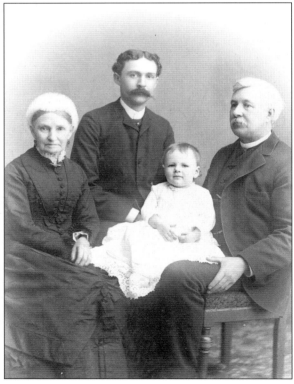

Four generations of Fays pose in June 1885. From left to right are Joanna R. Fay, Fred H. Fay, Dudley Ward Fay, and Edwin R. Fay. (Courtesy George Kerstetter.)

An inscription on this photograph reads, "Surprise Xmas present for father." Taken in December 1888, the image shows Flora Ward Fay and four-year-old Dudley Ward Fay. (Courtesy George Kerstetter.)

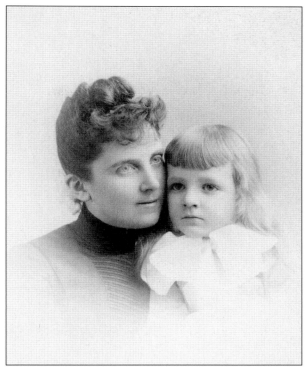

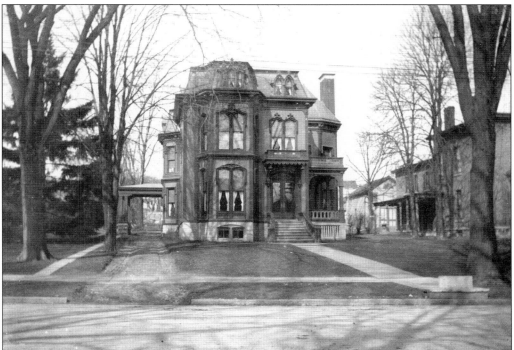

Pictured here is the original house of Fred and Flora Fay at 63 South Street. (Courtesy George Kerstetter.)

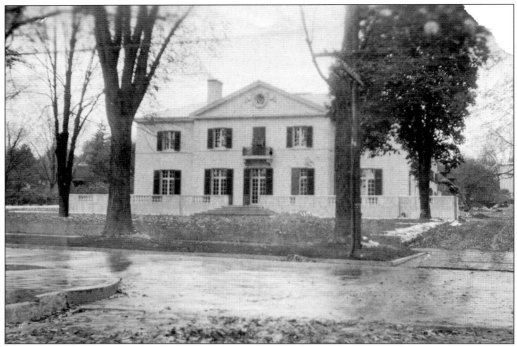

This is the new Fay mansion at 63 South Street. Isadora Duncan danced on the lawn for one of Flora Ward Fay's parties. Today, these are the Queen's Court Apartments. (Courtesy George Kerstetter.)

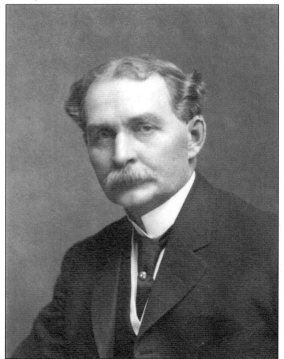

This image of Fred Hollister Fay shows a very different character than the 1885 photograph. What altered the features of that handsome, sensitive young man into a weary, almost cynical resignation? Perhaps this expression prompted Flora to refuse burial in the Fay mausoleum. Fred Fay died on January 26, 1926. Flora Fay died on December 6, 1926. (Courtesy George Kerstetter.)

A matronly Flora Ward Fay, presiding over her garden, pauses to pose for the camera. Her gardener Jorge Brown goes about his duties. (Courtesy George Kerstetter.)

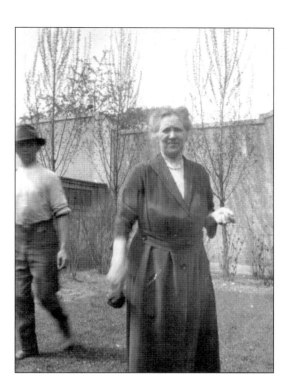

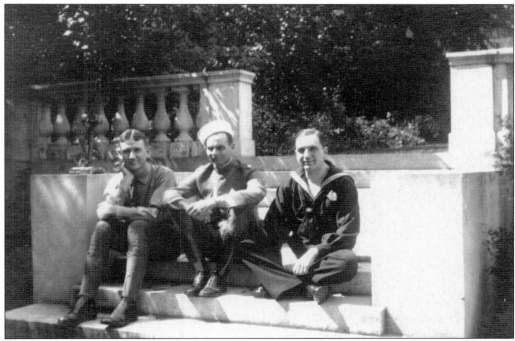

Dudley Fay, Bev Dunn, and Bill Fay pose in the backyard of the new 63 South Street. Dressed in their military uniforms, they enjoy a peaceful, sunny interlude before entering the "war to end all wars," which will change their familiar way of life forever. (Courtesy George Kerstetter.)

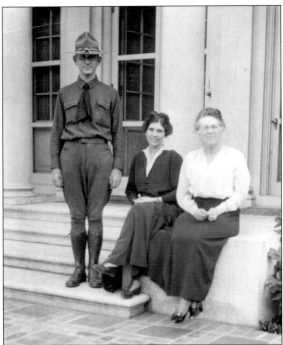

Willis, Helen, and Flora Ward Fay relax at the side entrance at 63 South Street in 1918. The Fays escaped the flu but not the war. (Courtesy George Kerstetter.)

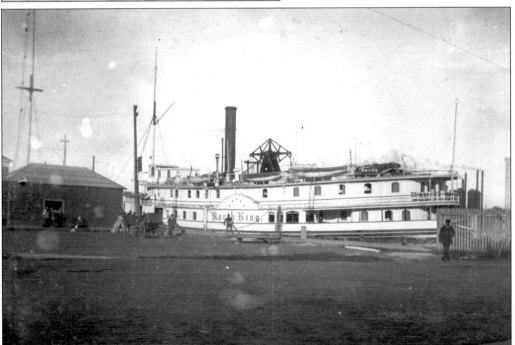

The steamboat *North King* arrives at Summerville. Flora Ward Fay hired this boat, or one very much like it, to take the sick and wounded soldiers returned from the war on a Great Lakes cruise of rest and relaxation. She opened her summerhouse on the lake as a retreat for the gassed and shell-shocked men to heal. (Courtesy George Kerstetter.)

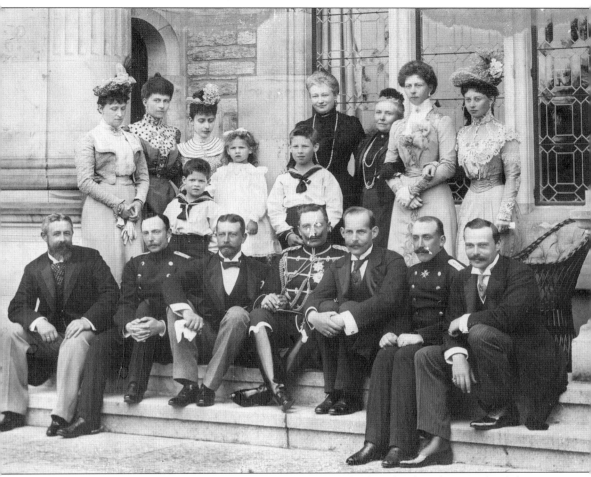

Flora Ward Fay was very interested in royalty. In Germany, she bought this photograph of the Empress Frederick and her son, Kaiser Wilhelm, and kept it on her dressing table. During World War I, her chambermaid Rose received a letter from a sister in England that complained of the shortage of food. In a fury, she took nail scissors and scratched the kaiser's face. Probably the chief attraction in the picture was the kaiser's brother, Prince Henry of Prussia, holding a handkerchief. Before the war, he was on a goodwill visit to the United States. Flora and her husband, Fred, met the prince driving on Fifth Avenue. Flora later insisted that he saluted her in return for her bow. Her husband maintained the salute was aimed at people in general. The group is the Empress Frederick, her sons and daughters, and their spouses. (Courtesy George Kerstetter.)

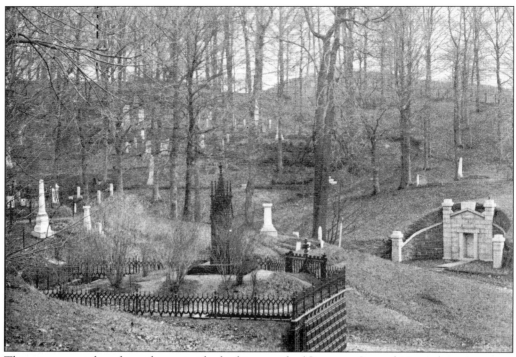

This view was taken from the east side, looking south. (Courtesy Seward House.)

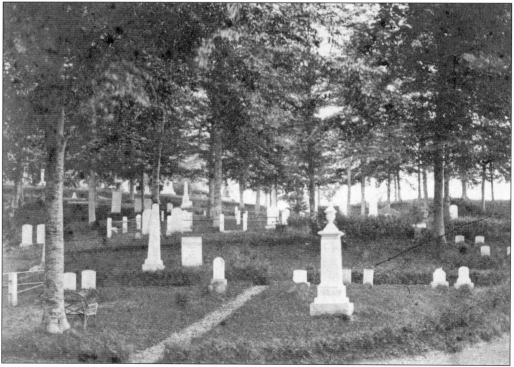

The view was taken from the south side, looking east. (Courtesy Seymour Library.)

Seven
SEWARD CARVED
IN STONE

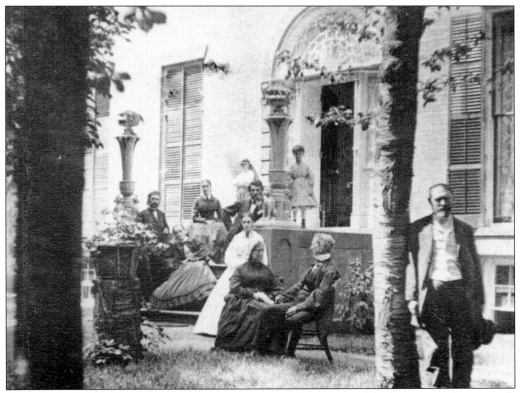

William H. Seward, his wife, daughter, and two sons share a peaceful afternoon gathering with family and friends. This is the front entrance, which faces east, of the Seward House, South Street. (Courtesy Seymour Library.)

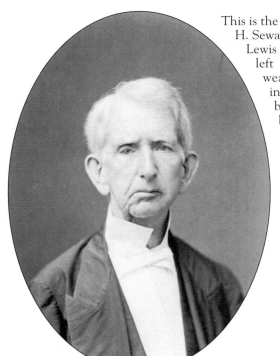

This is the only frontal photographic image of William H. Seward known to exist. The attack on Seward by Lewis Paine on the night of Lincoln's assassination left Seward scarred and disfigured. He was wearing a brace while recuperating from injuries received in a carriage accident. The brace protected Seward from being murdered by the vicious slashing of the knife wielded by Paine. (Courtesy Seward House.)

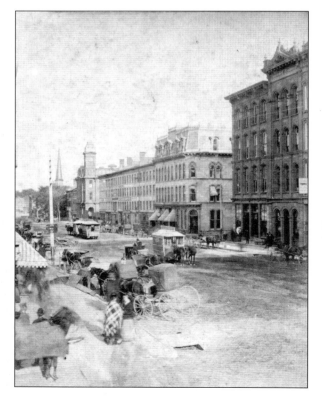

Seward Bank is the mansard-roofed building in the center of this c. 1890 photograph. The bank was located at the corner of Genesee and Exchange Streets. Seymour library was located upstairs until 1903. It is now the site of a mall. (Courtesy Seymour Library.)

Presiding at important family functions, Mrs. William H. Seward read words of solace and spiritual nourishment while seated at this table. From this photograph, American sculptor John Rogers created the statue that graces the parlor of the Seward House. (Courtesy Seward House.)

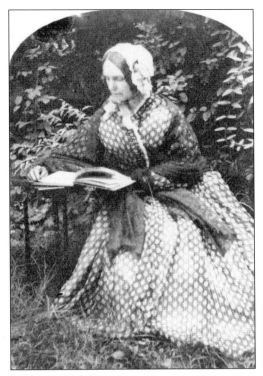

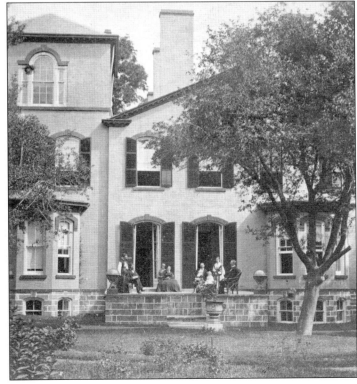

The Seward family gathers on the south verandah to enjoy a view of the gardens. (Courtesy Seymour Library.)

The Robinson family mausoleum is one of only three remaining crypts built into the side of a hill. This view is facing west from the wooded slope behind Fort Alleghan, leading to Consecration Dell to the left. Burr Circle is visible just above the top of the Robinson vault. The site to the far left was chosen by Judge Elijah Miller for his own final resting place and is marked by the box-shaped monument. It is the first burial in Fort Hill and will later include the Seward family plot. (Courtesy Seymour Library.)

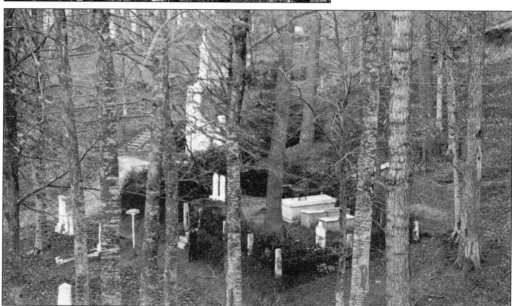

Much of the primeval forest remains intact, surrounding the few plots in Consecration Dell. Judge Elijah Miller is buried at the site of the white box-shaped monument right of center. Judge Miller strolled this site with his colleague Benjamin F. Hall on a July morning in 1851. Hall suggested the judge claim the first plot since Miller had been responsible for creating the cemetery. As Miller pondered the spiritual afterlife, a ray of sunshine broke through the fog and illuminated this site. He took that as a sign to choose it as his final resting place. He died the following November and was the first person buried there. (Courtesy Seward House.)

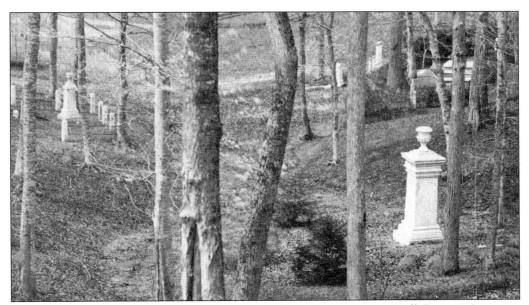

This photograph shows the Morgan-Pitney monument at Consecration Dell. Born in Aurora in 1810, Christopher Morgan studied in the law offices of Miller and Seward. He was married in 1832 to Mary Pitney, the daughter of Dr. Joseph Pitney. Morgan became the mayor of Auburn in 1860. When the Whig party dissolved, Morgan became an enthusiastic supporter of the new Republican Party. Morgan died on April 3, 1877. (Courtesy Cayuga Museum.)

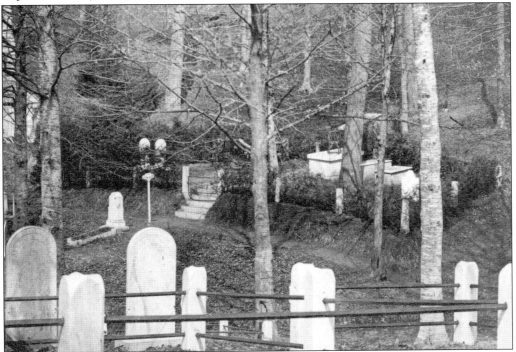

Looking north, the steep, wooded hill of Consecration Dell climbs behind Judge Miller's plot to emerge behind Logan's monument in Fort Alleghan. (Courtesy Seward House.)

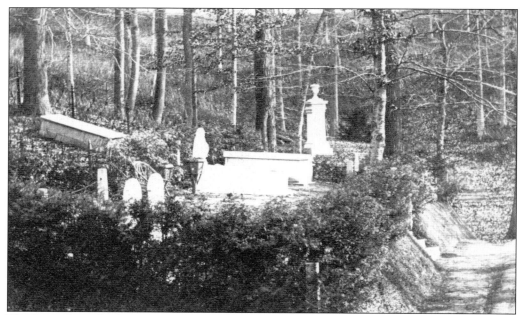

The Seward family plot is seen here in a photograph that is looking east. Mrs. Seward has joined her father, Judge Miller in the family plot. The Morgan-Pitney monument is the tall white stone with the urn on top that rises to the east of the Seward plot. (Courtesy Seward House.)

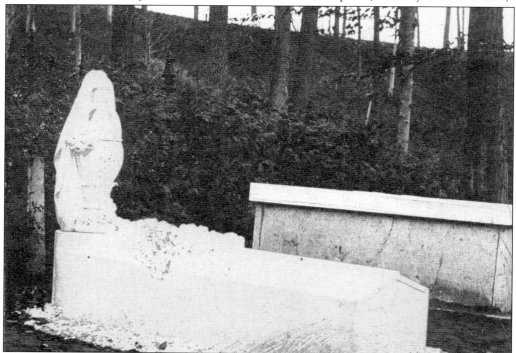

Petals of fresh flowers and a floral wreath adorn the new monument to Frances Adeline Miller Seward, buried next to her father, Judge Elijah Miller. Mrs. Seward died on June 21, 1865. (Courtesy Seward House.)

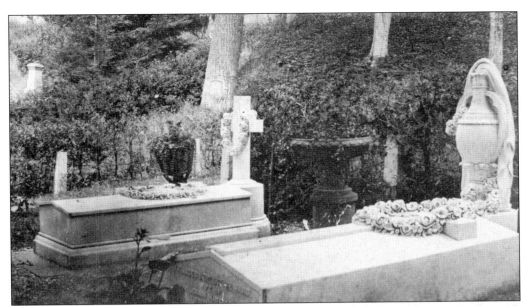

Another new monument occupies the Seward family lot. Fannie, the daughter of William H. and Frances A. Seward, has finished her brief life and gone to join her mother and grandfather in the sacred soil of Consecration Dell. Fanny fell ill after the attack on her father the night of Lincoln's assassination and never fully recovered. She died at age 21 on October 29, 1866. (Courtesy Seward House.)

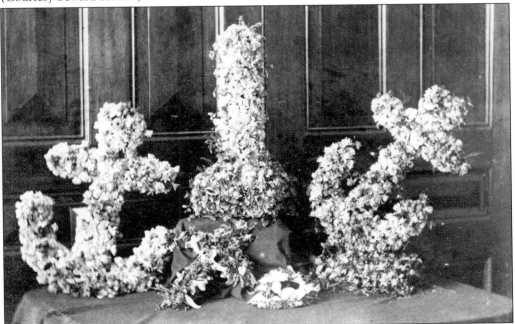

In October 1872, floral arrangements fill a table in the parlor of the Seward mansion. They are tribute to the memory of William H. Seward, New York governor, secretary of state for President Lincoln, and negotiator of the Alaska Purchase. Seward died on October 10, 1872, as he napped on his favorite couch. (Courtesy Seward House.)

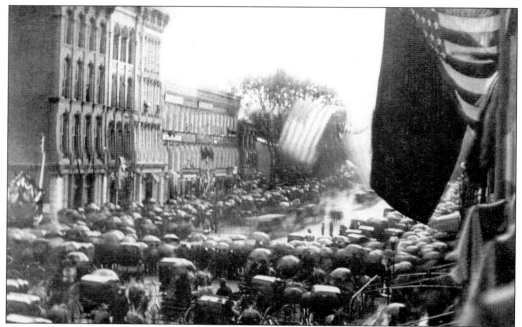

The city of Auburn convenes on Genesee Street to mourn the death of William H. Seward on a rainy October day in 1872. The procession slogs westward on Genesee Street to convene at Fort Hill. (Courtesy Seymour Library.)

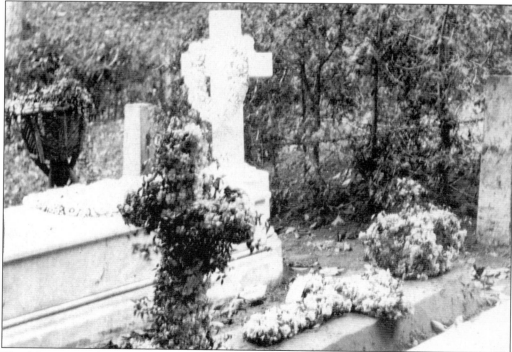

Floral bouquets adorn the carefully shaped soil covering the new grave of William Seward. He is buried between his wife and daughter. (Courtesy Seymour Library.)

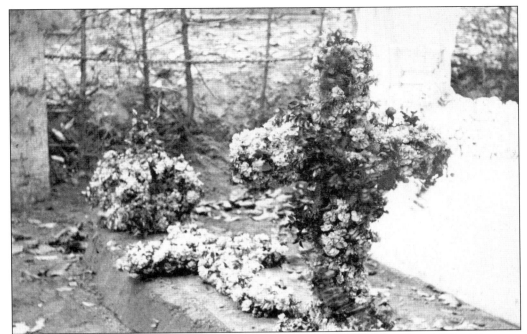

Floral tributes adorn the fresh grave of William H. Seward in October 1872. (Courtesy Seward House.)

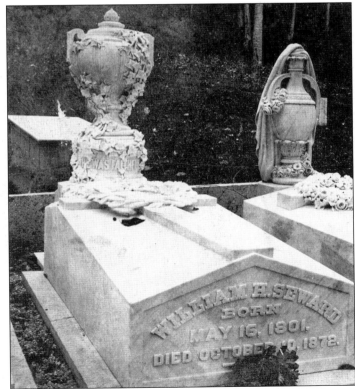

This memorial wreath sat at the foot of the monument for William H. Seward. (Courtesy Seymour Library.)

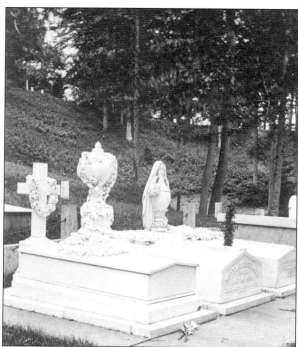

Three generations are remembered here in stone—Fanny Seward, William H. Seward, Frances A. Seward, and Elijah Miller. (Courtesy Seward House.)

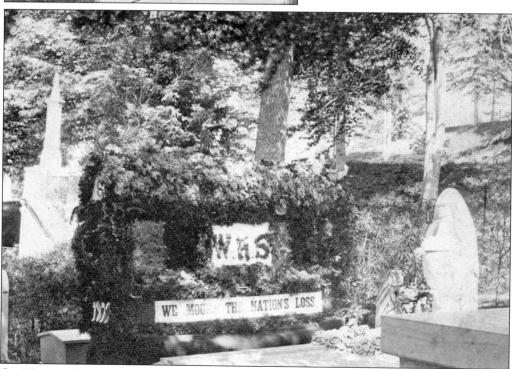

On Memorial Day 1873, the Seward Corps erected this elaborate floral canopy in tribute to William Seward. In this view facing west, the Pettit vault is still standing to the left. (Courtesy Seymour Library.)

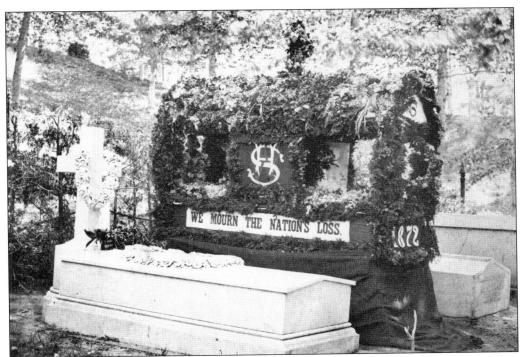

The Seward Corps floral tribute is seen here on May 30, 1873. (Courtesy Seymour Library.)

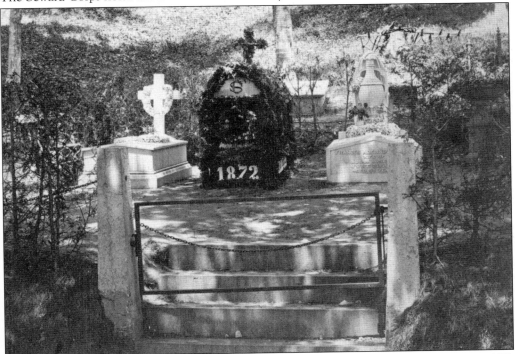

This memorial to William H. Seward was installed by the Seward Corps on May 30, 1873. (Courtesy Seward House.)

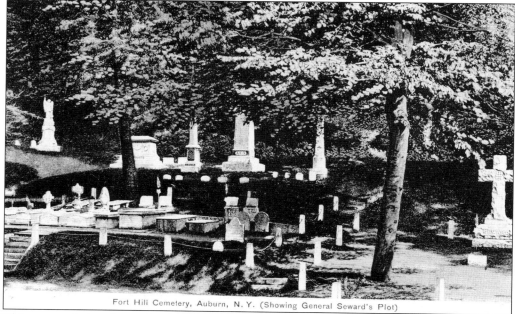

Fort Hill Cemetery, Auburn, N.Y. (Showing General Seward's Plot)

This postcard view shows the Seward family lot *c.* 1900. (Courtesy Lou and Myrtle Chomyk.)

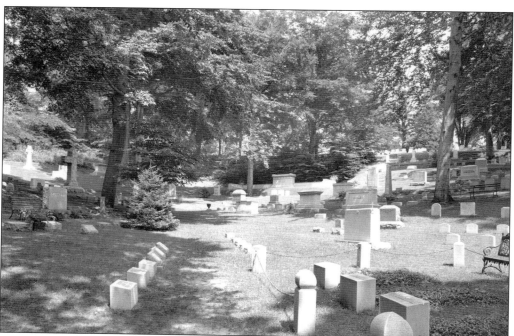

Consecration Dell has changed dramatically during the century since the dedication of the cemetery. The large white monument dominating the center is the Metcalf family plot. Col. Edwin D. Metcalf was the founder of the Columbian Rope Company, a major industry in Auburn for nearly a century. Below the Metcalf plot is the Underwood family plot, whose name graced the Fitch Avenue gate. (Courtesy Fort Hill Cemetery Association.)

78

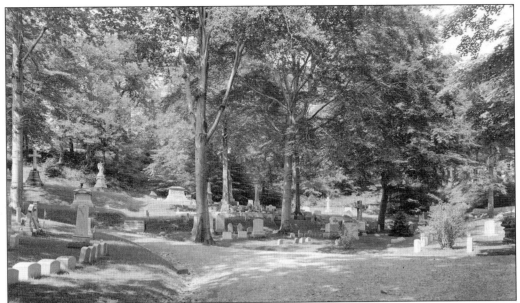

Trees in this 1951 image of Consecration Dell shade the Seward family plot. This marks the year of the death of William H. Seward III, who bequeathed the Seward House to become a museum. Note the ornate cast-iron fence is now missing from the mound to the lower left. Above that, to the far left, the Pettit vault is gone and the Gen. Clinton MacDougall monument (with the cross atop the stack of stones) sits above the site of the former mausoleum. (Courtesy Fort Hill Cemetery Association.)

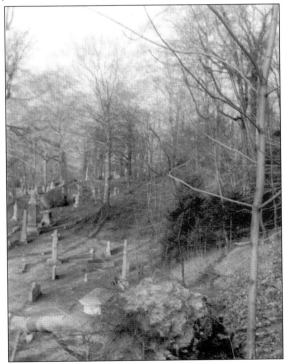

Winds in a 1950 storm uprooted a tree in Consecration Dell. (Courtesy Fort Hill Cemetery Association.)

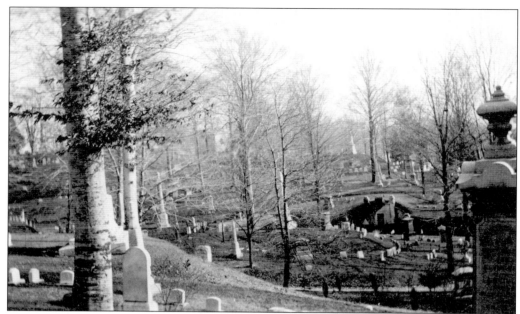

This view of Consecration Dell was taken from the south edge of the Porter-Beardsley plots. The Adams vault is across the way. The Fay mausoleum is on the hill left of center, and the Seward plot is to the far left. By May 30, 1914, the valley is beginning to fill up with stones while the primeval forest has dwindled. (Courtesy Community Preservation Committee.)

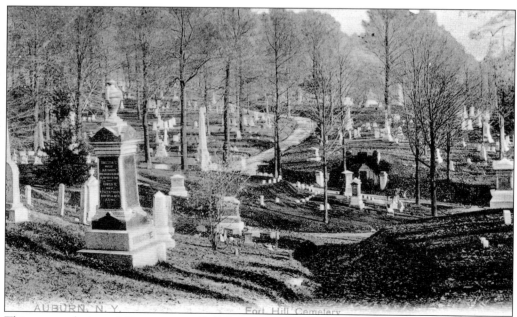

This postcard view of Consecration Dell faces southwest. (Courtesy Lou and Myrtle Chomyk.)

Eight

MISSING PIECES

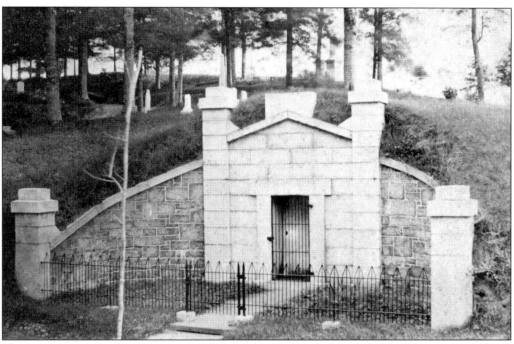

The motto on the lintel over the door reads, "C.B. Adams 1860." Adams was a local businessman. The gate and walk are gone; the entrance door was sealed after it was vandalized and desecrated. To the right, there is a stone inscribed "Julia Willis—Faithful unto Death." Julia was the Adams' housekeeper for several decades. She was buried outside the vault "to greet visitors as she had done for so long at the [Adams'] home," according to a 1951 newspaper article. A half century after this photograph was taken, the path under the trees at the left will lead past the monument of industrialist Samuel Laurie from Scotland; Theodore M. Pomeroy, politician and cofounder of American Express; George Clough, artist; the Fay mausoleum for the family of bankers; and, off to the right, Charles Schweinfurth, father of Julius A., the architect who designed Bradley Chapel. (Courtesy Seymour Library.)

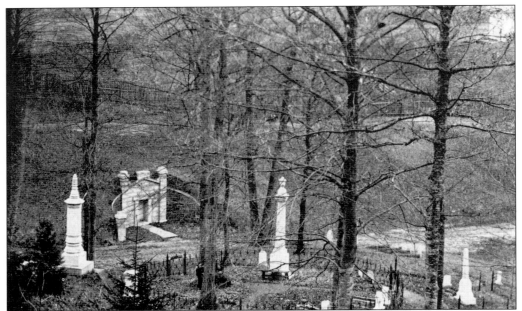

Looking south from above the Robinson vault where Consecration Dell and Glen Alpine merge. The Adams family's vault dominates the valley. Adams is one of the three remaining crypts. The white column at the left marks the site of the Pettit vault, which no longer exists. (Courtesy Seymour Library.)

The perimeters of the old section of the grounds slope gently down to flat terrain. This appears to be part of the broad expanse of the western sections of the cemetery. (Courtesy Seward House.)

A second mystery: the Curtis family's vault (lower right) has also vanished. Located approximately 90 degrees from both the Adams and Pettit vaults, the dark stone, iron fence, and ornate monument of the Curtis lot in this image has given way to a plain square plot with few stones. The view is facing northeast through the wooded glen of Consecration Dell. The stone of Elijah Miller is located just above center. Decades after this image was recorded, the Metcalf, Underwood, McIntosh, Wait, Hislop, and Sefton clans will share plot space adjunct to the Seward, Dulles, and Morgan families. William Miller Collier, an ambassador to Chile and Spain, will come to join them. (Courtesy Seymour Library.)

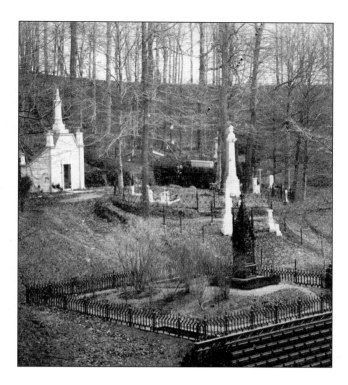

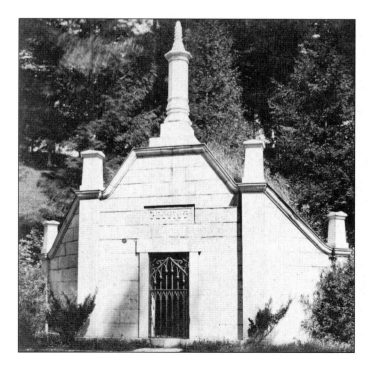

This photograph shows a close-up of the Pettit vault. The column at top center and two of the square top stones are all that now remain of this once elegant mausoleum. Individual stones mark the graves of the family members. Why this site was so radically changed remains a mystery. (Courtesy Seymour Library.)

In this view looking north from the Adams vault, the Robinson vault is on the left, the Pettit vault on the right. Still living at the time of this photograph, Gen. John S. Clark will be buried on the ridge above the Pettit vault (to the left), and the monument for Gen. Clinton MacDougal will be to the right—although when he died in Paris in 1914, he was buried in Arlington Cemetery. MacDougal was a partner with W.H. Seward II in the Seward Bank business. (Courtesy Seymour Library.)

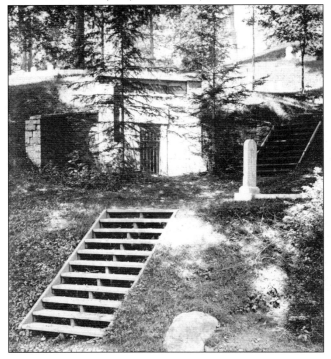

These wooden steps ascend the slope past the Robinson vault, leading to the crest of Glen Haven. The path leads counterclockwise to the slope descending to Burr Circle. The Groot family lot, defined by the stone circle above the vault, will become a popular site for vandalism and cult activity. (Courtesy Seymour Library.)

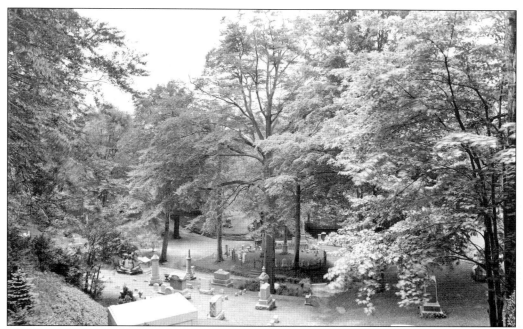

This view looks south across Glen Haven to Glen Cove Dell *c.* 1951. The Adams vault is obscured by the trees in the center. The Pettit column is left of center, and the vault is gone. The John S. Clark monument is at the right. (Courtesy Fort Hill Cemetery Association.)

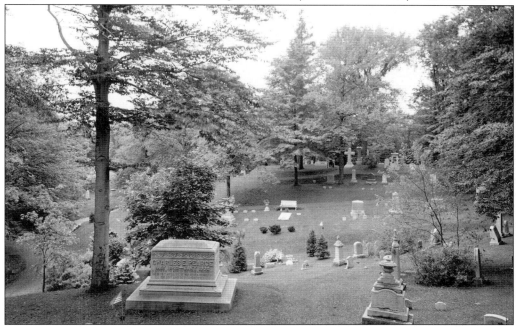

Looking south from Glen Alpine to Mount Hope, this view shows the site of the Throop-Martin and Hatch family plots. Myles Keogh's monument is just to the right of the white stone cross. Vandals smashed the ornate stone bench near the center of the image in the early 1980s. (Courtesy Fort Hill Cemetery Association.)

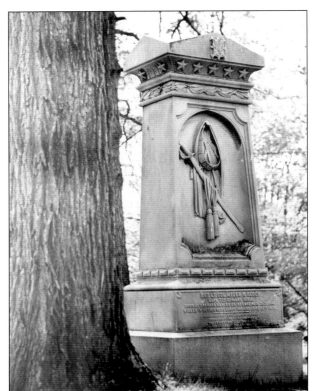

This is a detailed photograph of the Myles Keogh monument, Throop-Martin plot, Mount Hope. Born in Ireland, Keogh was a member of the Papal Guard before coming to America to join the military. There he met Andrew Alexander, husband of Evelina Martin Alexander of Willowbrook. Their ancestor, former governor Enos T. Throop, established the estate. Keogh became a frequent visitor and friend of the Throop-Martin families Through their intervention, Keogh was brought back to Auburn to be buried in the family plot after he was killed at the Battle of Little Big Horn on June 25, 1876. (Courtesy Fort Hill Cemetery Association.)

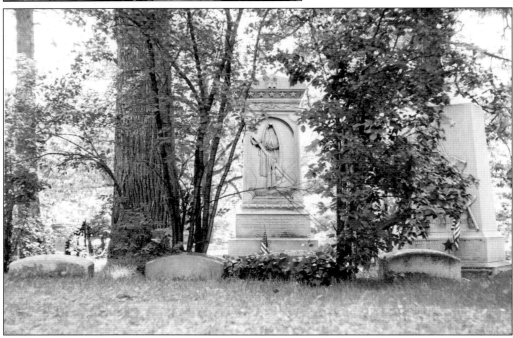

Monuments to Myles Keogh and Andrew Alexander share vigil over the Throop-Martin family plot. (Courtesy Fort Hill Cemetery Association.)

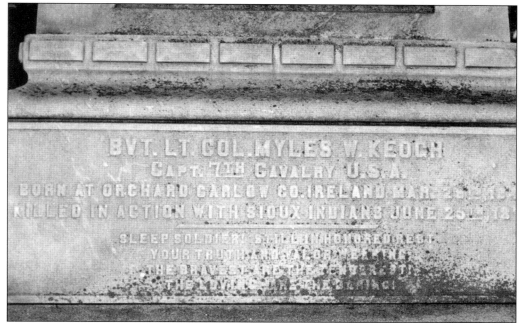

"Sleep Soldier! Still in Honored Rest / Your Truth and Valor Wearing / The Bravest are the Tenderest! / The Loving the Most Daring!" This touching inscription on his monument may support the popular legend of unrequited romance between Keogh and Cornelia Martin, sister of Evy Alexander. (Courtesy Fort Hill Cemetery Association.)

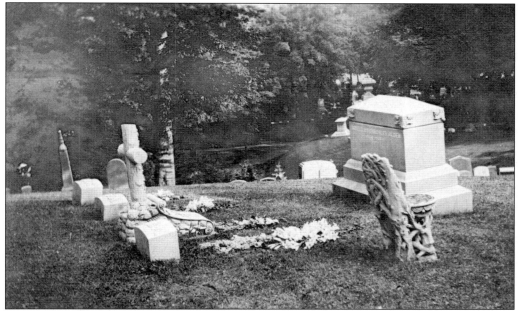

The Alden family plot is adjacent to A.G. Beardsley, at the crest of Glen Alpine overlooking Sunny Side. The lot is decked out with fresh floral arrangements for Memorial Day 1914. Note the ornate monument with cross and stone chair, typical of the Victorian-era mourning sensibilities. (Courtesy Community Preservation Committee.)

This view of the A.G. Beardsley plot shows the adornment of the Memorial Day flowers of 1914. (Courtesy Community Preservation Committee.)

This is the Beardsley plot without the flowers and ornate furniture. The Groot family plot, with stone circle, is in center background. (Courtesy Community Preservation Committee.)

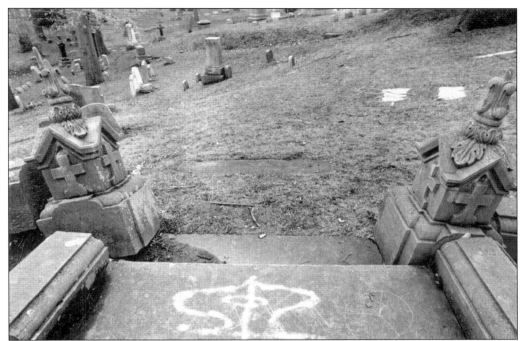

A cult symbol is spray-painted on the western step to the Groot family plot, Sunny Side. This site is attractive to cult and other nefarious activities because it commands lookout vantage point and easy escape. (Courtesy author's collection.)

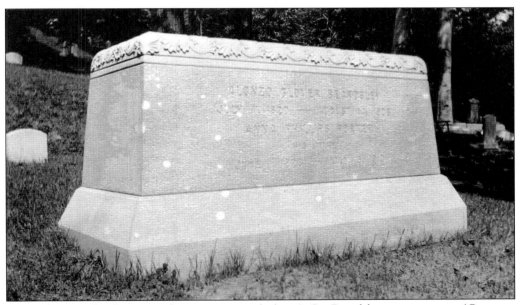

This photograph shows a close-up view of the A.G. Beardsley monument. (Courtesy Community Preservation Committee.)

This business envelope is from the Oswego Starch Factory. This successful business enriched several of the executives of Auburn. The Kingsford brothers of New Jersey, formerly of England, had patented a process for making cornstarch, a product superior to potato starch. Dr. Sylvester Willard was president of the company for many years. This stationery indicated Alonzo Glover Beardsley as one of the partners in the business. (Courtesy Community Preservation Committee.)

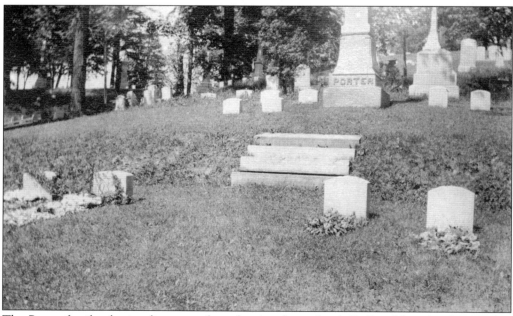

The Porter family plot is adjacent and on the tier above the A.G. Beardsley plot. Mrs. Helen Beardsley was a Porter. (Courtesy Community Preservation Committee.)

This postcard view shows the Paul Woodruff monument, as seen from Burr Circle. The Porter and Beardsley lots are behind and above the Woodruff lot, Glen Alpine. (Courtesy Lou and Myrtle Chomyk.)

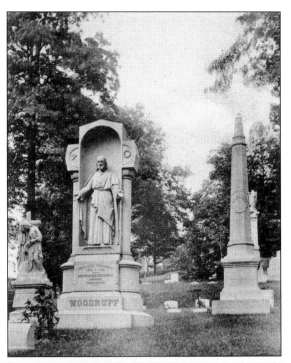

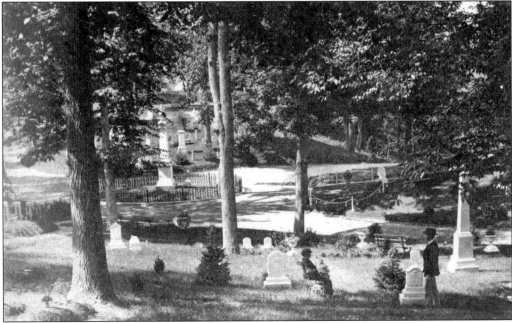

This is the bottom of Glen Alpine, looking south to Laurel Hill. An ornate cast-iron fence depicting grapes and vines surrounded Burr Circle, in the center. The top of Laurel Hill is the family plot of Josiah Barber, an early Auburn industrialist who operated a woolen mill. The two men appear to be enjoying the tranquil scene blending nature and the best of Victorian-era cemetery accessories. (Courtesy Seymour Library.)

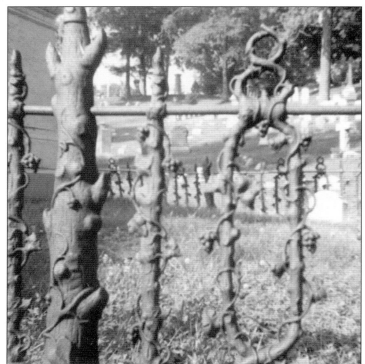

A detail of the grapevine design in the cast-iron fence surrounding Burr Circle is seen here *c.* 1982. (Courtesy author's collection.)

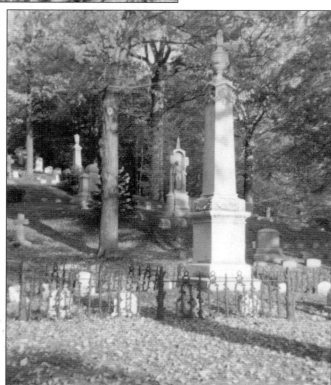

The Burr Circle once had a cast-iron fence, as shown in this *c.* 1982 image. It was removed about 10 years later. (Courtesy author's collection.)

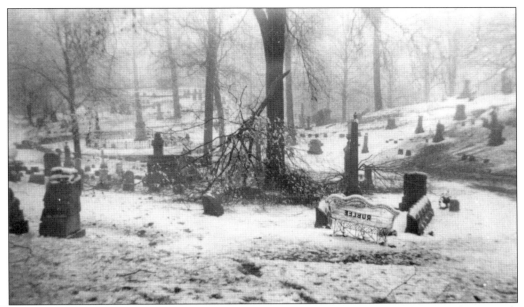

A storm in March 1936 assaults the trees, breaking branches, and draping the monuments with a layer of thick, wet snow. Note the wicker bench with the name "Roblee," which appears to be ignoring the elements. This view of Glen Alpine is looking south toward Burr Circle and the Barber family plot. (Courtesy Fort Hill Cemetery Association.)

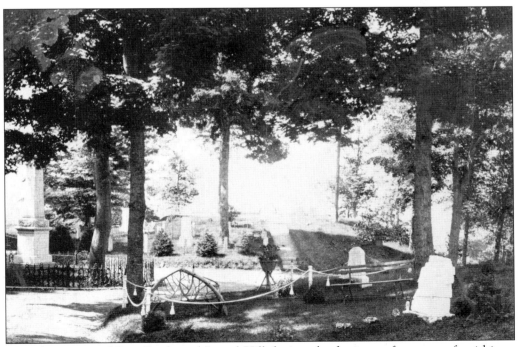

This closer view of Burr Circle and Laurel Hill depicts the fussiness of cemetery furnishings. Note the rustic furniture, the swag fence with tassels, the footed urn for plants, and the tiny vase at the base of the ornate white stone. (Courtesy Seymour Library.)

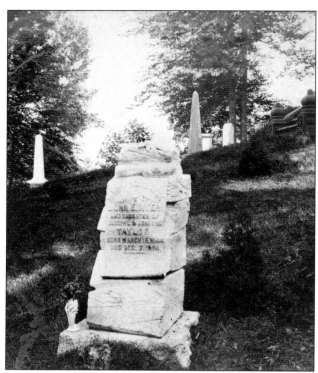

This close view captures the Myer-Taylor monument. Note the porcelain vase shaped like a tulip held by a delicate hand. This vase, or one identical, is in the collection of the Cayuga Museum. A plainer one has since replaced the monument. The ornate steps at the upper right mark the entrance to the Fitch family plot. Abijah Fitch was another early Auburn industrialist. Fitch's daughter was married to Theodore Pettibone Case, grandfather of Theodore W. Case, the inventor of sound film. (Courtesy Seymour Library.)

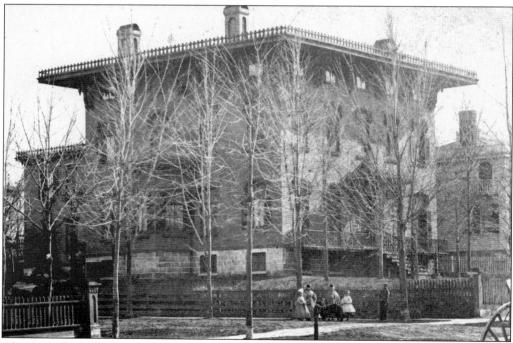

Abijah Fitch resided on Genesee Street. Fitch, a factory owner, built company housing for his employees. This cluster of houses was identified on early maps as "Fitchville," on Clark Street near Washington Street. (Courtesy Seymour Library.)

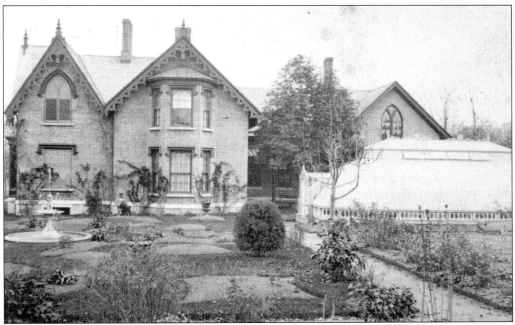

Shown here is Josiah Barber's residence, located on the corner James and Clark Streets. Barber owned an early woolen mill. He died on May 1, 1880, and is buried on Laurel Hill. His house is now the office of Homsite Development Corporation, creators of the Fort Hill Square historic neighborhood at Fort Street and Westlake Avenue. (Courtesy Seymour Library.)

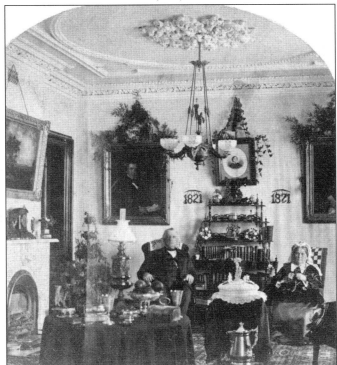

Josiah and Mrs. Barber pose proudly in their parlor at 60 Clark Street for their portrait to commemorate their golden wedding anniversary in 1871. (Courtesy Seymour Library.)

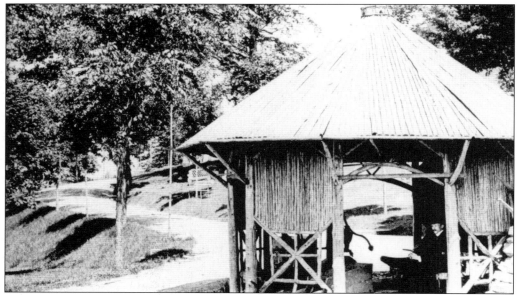

This "summerhouse" was a gazebo where the weary visitor to the cemetery could sit in the shade and pour a drink of fresh cool water from the pump. The Barber family lot is on top of the hill directly behind the gazebo. To the right is the Rathbun family plot, and to the left is the border of the lot designated for the Home for the Friendless—an institution created in 1865 on Grant Avenue for Civil War widows. (Courtesy Cayuga County Historian.)

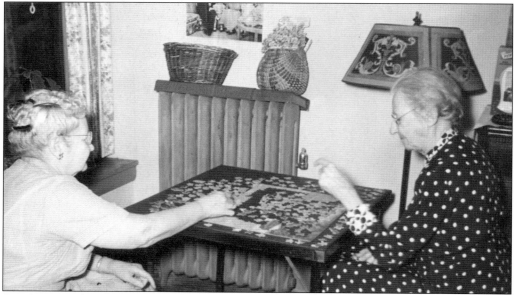

Sue Spoor and Emma Hurd share the challenge of a jigsaw puzzle in "the Home" in 1953. Originally named the Home for the Friendless, the institution was established in 1865 as a retreat for Civil War widows. It evolved into a retirement home for senior women. Now called the Faatz-Crofut Home, it has been open to both men and women since the 1980s. Hurd, born in 1860, lived to 103 years of age. She took her first airplane trip at age 100 when she traveled to Boston. (Courtesy Faatz-Crofut Home.)

The gazebo is shown just before the ropes were pulled to bring it down in November 1950. Notice how it leaned toward the east. All posts broke off when pulling began. (Courtesy Fort Hill Cemetery Association.)

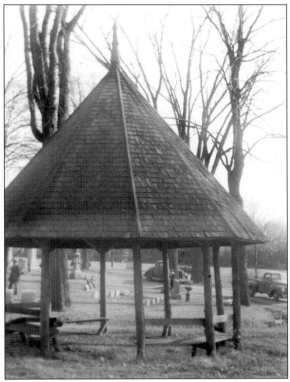

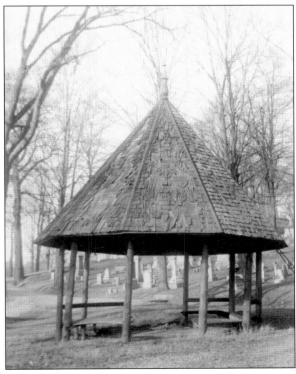

The gazebo was destroyed due to its deteriorating condition. (Courtesy Fort Hill Cemetery Association.)

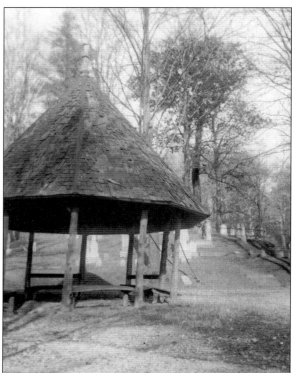

Ropes were attached to support the beams of the gazebo, which is ready to be pulled down in November 1950. The Rathbun family plot is in the background. (Courtesy Fort Hill Cemetery Association.)

The roof dropped to the ground when the posts gave way in pulling the gazebo down. (Courtesy Fort Hill Cemetery Association.)

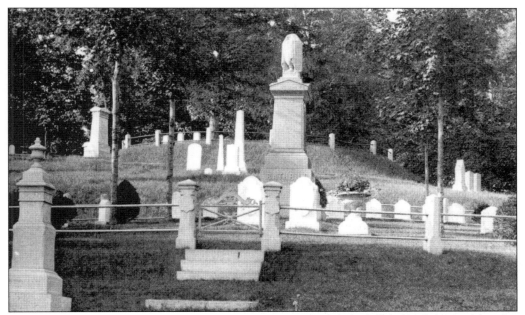

The Rathbun family plot is seen here in a view facing north. The hill behind the Rathbun lot is Mount Hope, where George W. Hatch, one of the original owners of the Fort Hill property is buried. To the left is the Throop-Martin family lot, showing the reverse of the Myles Keogh monument. (Courtesy Cayuga County Historian.)

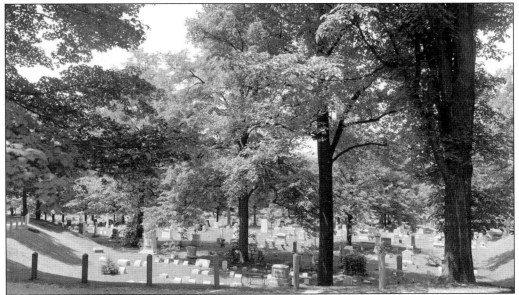

This view looks down from the Fitch family plot, west across Evening Dell toward West Lawn. Harriet Tubman's grave is in the distance, but the trees on the western most edge of the cemetery obscure it. Rev. William Hubbard and Rev. Ransom Bethune Welch, important figures in the Auburn Theological Seminary, are buried in Evening Dell. Their large white stones appear to the left and right, respectively, of the tree just left of center. (Courtesy Fort Hill Cemetery Association.)

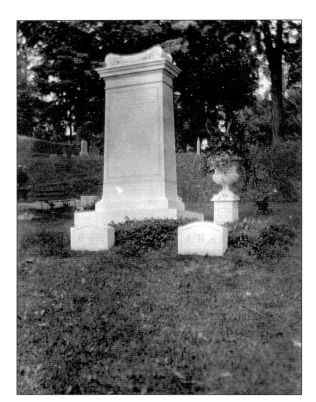

This monument for Rev. William Hubbard was erected on May 30, 1914. The Presbyterian minister died on January 31, 1913. According to his obituary, he literally worked himself to death. (Courtesy Community Preservation Committee.)

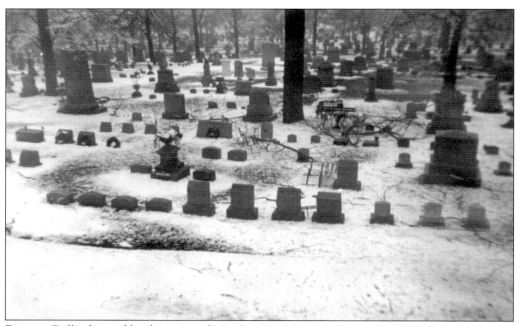

Evening Dell is littered by the storm of March 1936. (Courtesy Fort Hill Cemetery Association.)

This is the monument of Ransom Bethune Welch, professor at Auburn Theological Seminary. It was carved by Herbert G. Adams. (Courtesy author's collection.)

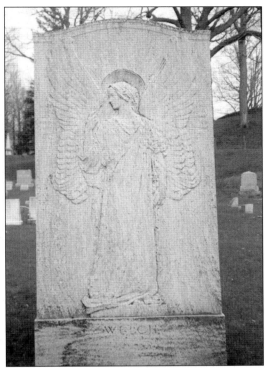

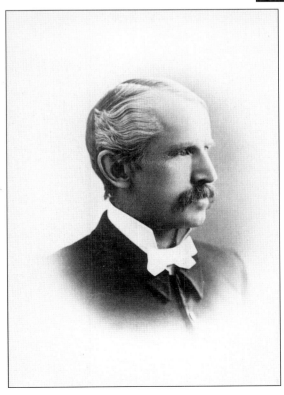

Dr. Ransom Bethune Welch was born on January 27, 1824, in Greenville, New York. He succeeded Dr. Edwin Hall in 1876 as professor of Christian theology at the Auburn Theological Seminary. He graduated from Union College in 1846 and from Auburn in 1852. Dr. Welch died on June 29, 1890. A gift of $30,000 from his estate helped endow the Welch Memorial Building adjacent to Willard Chapel. (Courtesy Community Preservation Committee.)

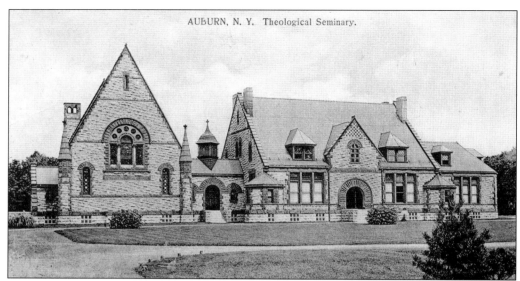

Willard Memorial Chapel and Welch Memorial Building are seen here on the former campus of Auburn Theological Seminary. Ransom Bethune Welch (a professor of Christian theology at Auburn Theological Seminary) died in 1890, leaving an endowment to create a new classroom building. The Willard sisters, Caroline and Georgianna, gave $50,000 to create a memorial chapel to their parents, Dr. Sylvester and Jane Willard. Dr. Willard was secretary of the board of trustees of Auburn Theological Seminary for 40 years. The Tiffany Glass and Decorating Company was engaged to design and outfit the entire interior of the chapel. "The Tiffany Treasure of the Finger Lakes" is now a registered historic site, owned and operated by the Community Preservation Committee. (Courtesy Community Preservation Committee.)

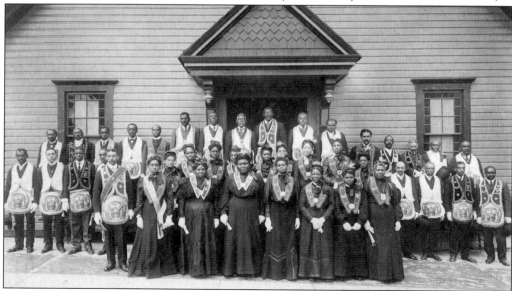

This photograph was taken in front of the Thompson Memorial AME Zion Church, on Parker Street, in 1905. A member of this congregation, Harriet Tubman willed her property to this church in 1906. These members of the Household of Ruth, dressed in their ritual regalia, represent several prominent leaders in the black community. (Courtesy Pauline Johnson.)

Nine
AUNT HARRIET

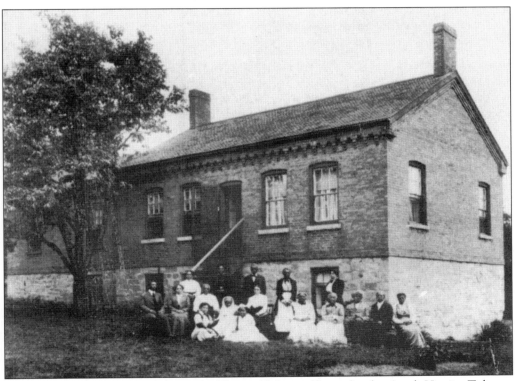

This contemporary postcard shows the Harriet Tubman Home for the Aged. Harriet Tubman and the AME Zion Church opened it in 1908. This had been her dream for many years. She became an inmate in 1912 and died here on March 10, 1913. Here she is seated and draped in a shawl. (Courtesy Harriet Tubman Home.)

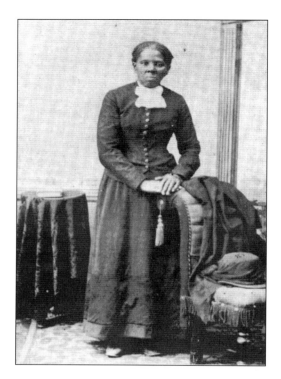

This postcard depicts Harriet Tubman (*c*. 1820–1913), a leader on the Underground Railroad. She made at least 19 trips into the South and led more than 300 slaves to freedom. She was a member of the AME Zion Church and willed her home and 26 acres of land to the church in 1906. (Courtesy Harriet Tubman Home.)

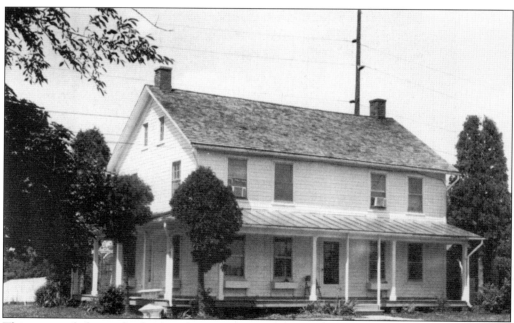

This postcard shows the home of Harriet Tubman, which is now owned by the AME Zion Church. It was rebuilt in 1952. In 1979, the interior was restored, using matching grant from the U.S. Department of the Interior, to represent period she lived there, from 1860 to 1913. It is now listed on the National Register of Historic Places. (Courtesy Harriet Tubman Home.)

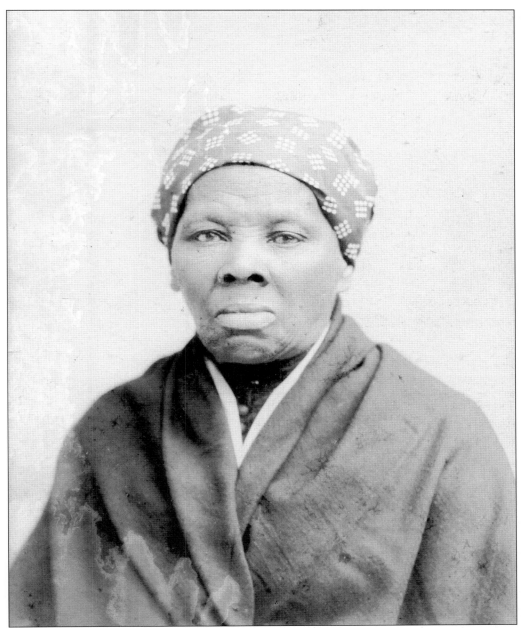

Harriet Tubman—or "Aunt Harriet," as she was known—was born a slave in Maryland. She escaped to the North and became a scout, spy, and nurse during the Civil War. She successfully aided at least 300 slaves to escape bondage during the most dangerous and grueling conditions imaginable, earning her the sobriquet "the Moses of her people." At one time, the Confederacy placed a bounty on her of $40,000, confirmation that she was a significant threat to the rebel cause. She retired to Auburn after the war, creating a haven for destitute former slaves based on the example of the Home for the Friendless, which would not admit African American women at that time. Aunt Harriet died on March 10, 1913. (Courtesy Cayuga Museum.)

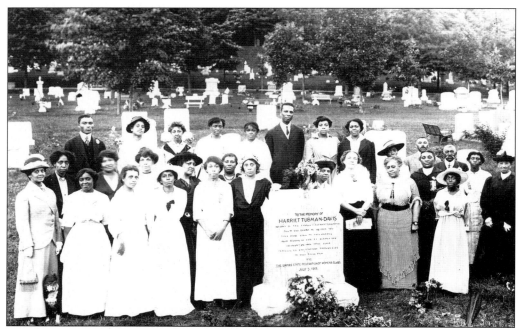

In July 5, 1915, the Harriet Tubman Club of New York City and the Empire State Federation of Women's Clubs dedicated the Harriet Tubman memorial monument. Lena Johnson is fifth from the right. (Courtesy Pauline Johnson.)

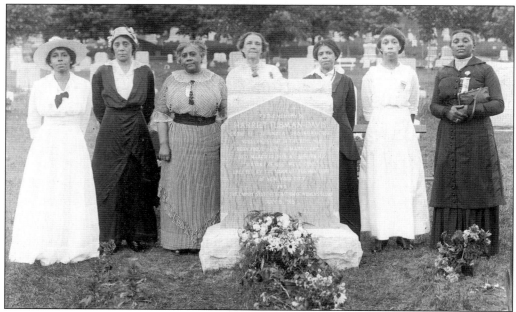

"To the Memory of Harriet Tubman Davis, Heroine of the Underground Railroad, Nurse and Scout in the Civil War, Born about 1820 in Maryland, Died on March 10, 1913 at Auburn, N.Y., 'Servant of God Well Done,' Erected by the Harriet Tubman Club of New York City and The Empire State Federation of Women's Clubs, July 5, 1915." Lena Johnson is on the far right. (Courtesy Pauline Johnson.)

This image of William Henry Stewart Sr., brother of Harriet Tubman, is from an early tintype. (Courtesy Judith Bryant.)

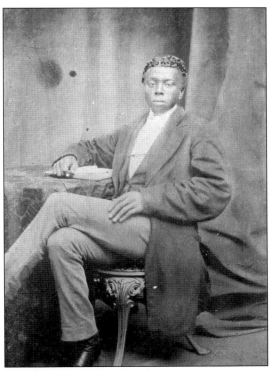

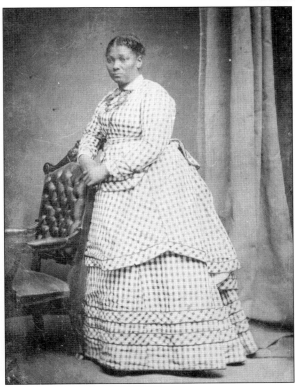

This early tintype shows "Grandmother" Stewart, wife of William Henry Stewart Sr. (Courtesy Judith Bryant.)

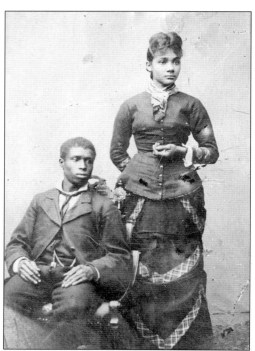

Mr. and Mrs. William Henry Stewart Jr. are captured here in an 1880 tintype. (Courtesy Judith Bryant.)

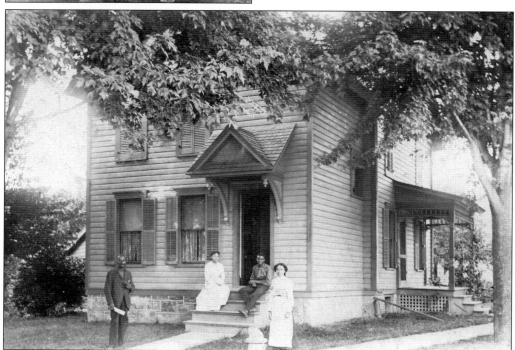

Shown here, from left to right, are William Henry Stewart Jr., nephew of Harriet Tubman; Emma Moseby Stewart, his wife; and their children, Charles Edward Stewart and Alida Maud Stewart. The picture was taken at 64 Garrow Street in Auburn, New York, c. 1901. (Courtesy Judith Bryant.)

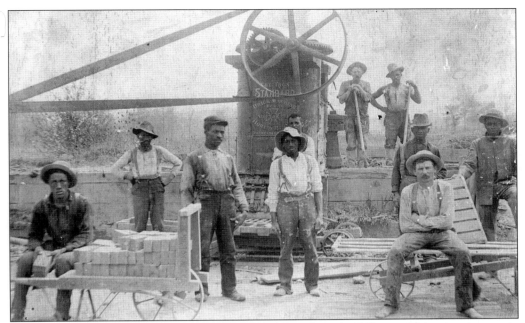

This 1910 photograph shows a brickmaking site located south of Harriet Tubman property in Fleming, New York. Charles E. Stewart, grandnephew of Harriet Tubman, is at the far right. (Courtesy Judith Bryant.)

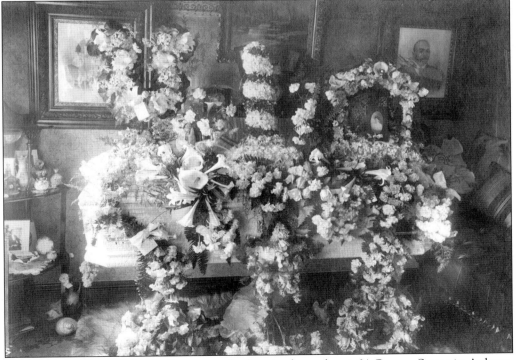

The funeral of Emma Moseby Stewart took place in the parlor at 64 Garrow Street in Auburn, New York, in 1912. (Courtesy Judith Bryant.)

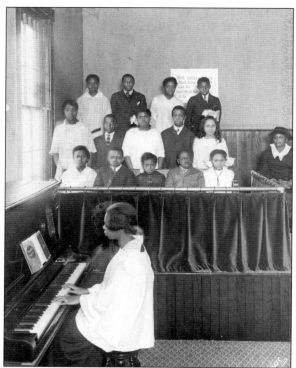

The Thompson Memorial AME Zion Church choir is shown here in 1916. The choir members are, from left to right, as follows: (front row) Dorothy Henderson, Howard Brown, Myrtle Brown, Maruice Winslow, and Amy Fonvielle; (middle row) Elnora Richardson, Walter Thompson, Althea Stewart, Knox Fonvielle, and Gladys Stewart; (back row) Margaret Richardson, Vernon Johnson, Edna Copes, and Frederick Winslow. Seated at the right is Lena Johnson, choir director. Mary Baker is at the piano. (Courtesy Judith Bryant.)

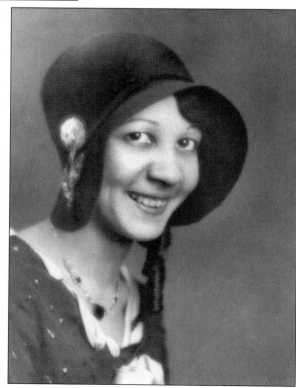

Gladys Alida Stewart is pictured here c. 1927. (Courtesy Judith Bryant.)

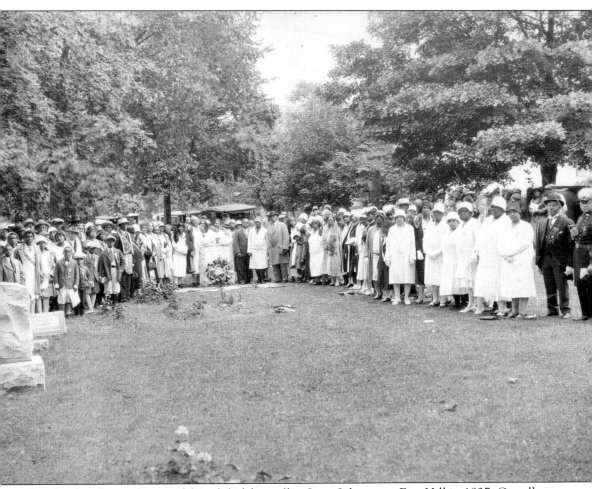

Family, church members, and friends bid farewell to Lena Johnson at Fort Hill in 1927. Carroll
H. Johnson, her son, is standing to the right of the monument. (Courtesy Judith Bryant.)

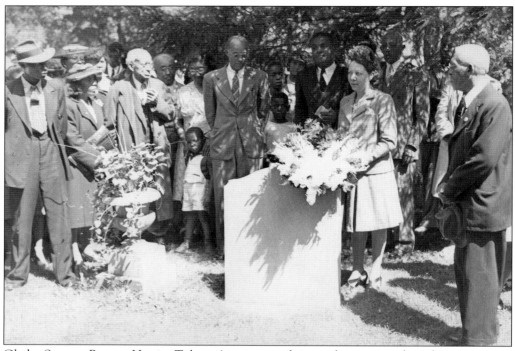

Gladys Stewart Bryant, Harriet Tubman's great-grandniece, places a wreath on her monument on September 3, 1945. The man at the right is Rev. E.U.A. Brooks.

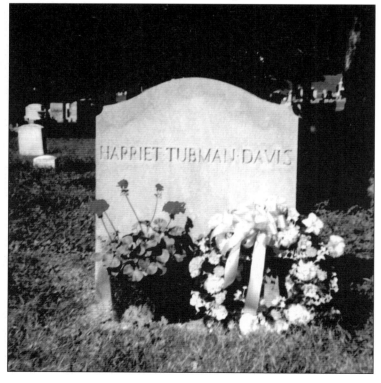

This monument to Harriet Tubman was installed in 1937, replacing the original, which was placed July 5, 1915. The photograph was taken in 1981. (Courtesy author's collection.)

Ten
BACK TO THE FUTURE

This path takes the traveler
north, as indicated by the
directions on this sign at
another intersection in the
heart of the cemetery.
(Courtesy Seymour Library.)

This view from an old section of the cemetery comes from an early stereo card. (Courtesy Seymour Library.)

This view from another section of the cemetery also comes from an early stereo card. (Courtesy Seymour Library.)

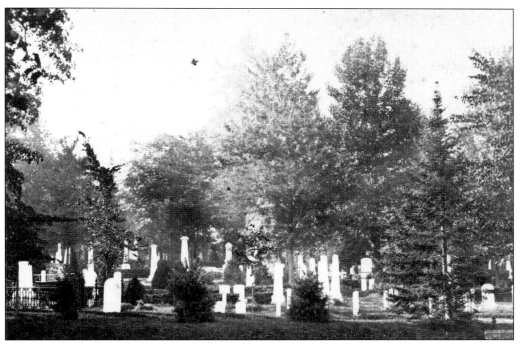

The flat terrain shown here indicates that this section is to the east, south, or west of the central peaks and valleys at the heart of the cemetery. (Courtesy Seymour Library.)

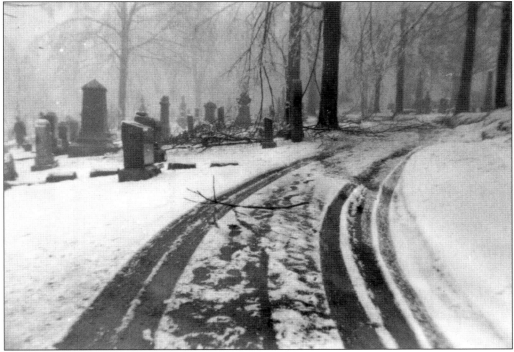

Slush from the storm of March 1936 records traffic through one of the old sections of the cemetery. Note the rabbit tracks to the right. (Courtesy Fort Hill Cemetery Association.)

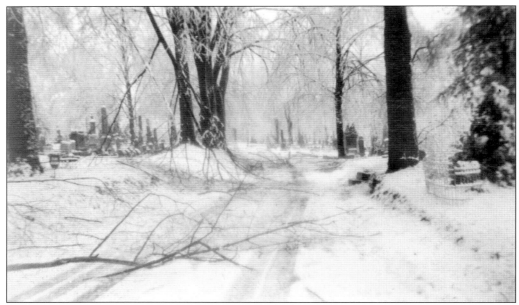

Ice, snow, and broken branches disguise the identity of this section, captured here after the storm in March 1936. (Courtesy Fort Hill Cemetery Association.)

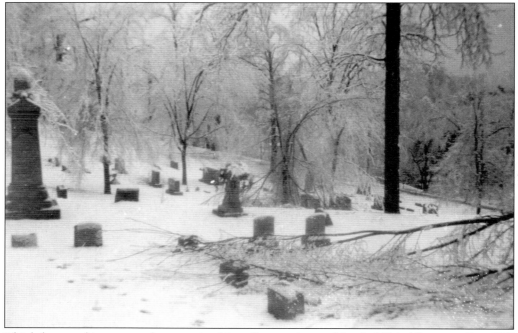

Thick layers of ice prune the trees in this valley section in March 1936. (Courtesy Fort Hill Cemetery Association.)

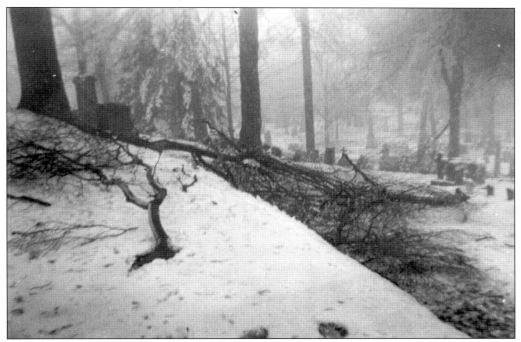

This barrier of broken limbs weighted with ice stopped the photographer in his tracks in March 1936. (Courtesy Fort Hill Cemetery Association.)

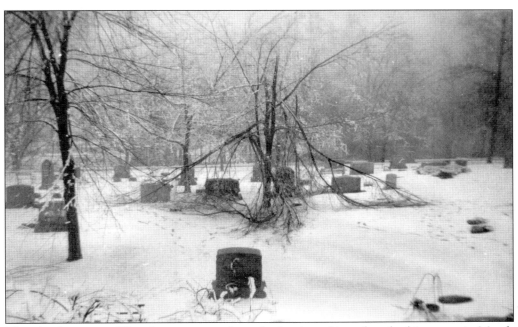

This slender tree in West Lawn swoons from the burden of ice after the big storm in March 1936. (Courtesy Fort Hill Cemetery Association.)

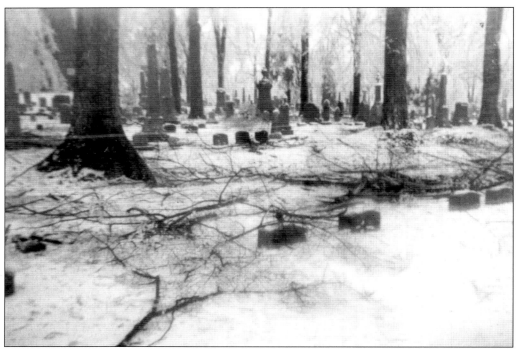

Icy remnants of trees weave a nest among the monuments in the south section in this March 1936 view. (Courtesy Fort Hill Cemetery Association.)

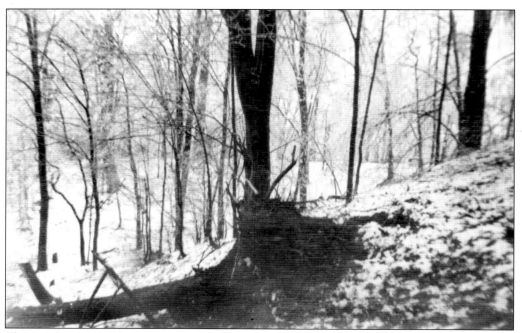

The weight of ice pulled this tree out by the roots. (Courtesy Fort Hill Cemetery Association.)

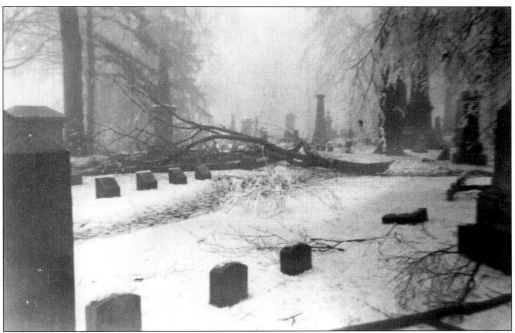

An elm tree succumbs to the weight of the ice. (Courtesy Fort Hill Cemetery Association.)

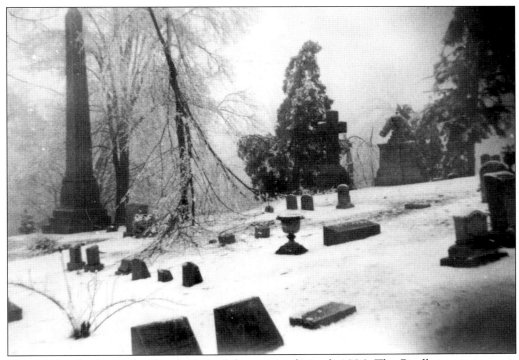

The north side shares the destruction of the storm of March 1936. The Bradley monument is at the left. (Courtesy Fort Hill Cemetery Association.)

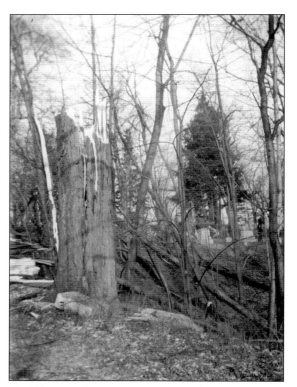

Winter isn't the only weather to wreak havoc with the grounds. This summer storm of 1950 broke branches and flattened trees such as this one atop the ravine east of Fort Alleghan. (Courtesy Fort Hill Cemetery Association.)

Branches broken in the wind threaten to topple monuments from their bases c. 1950. (Courtesy Fort Hill Cemetery Association.)

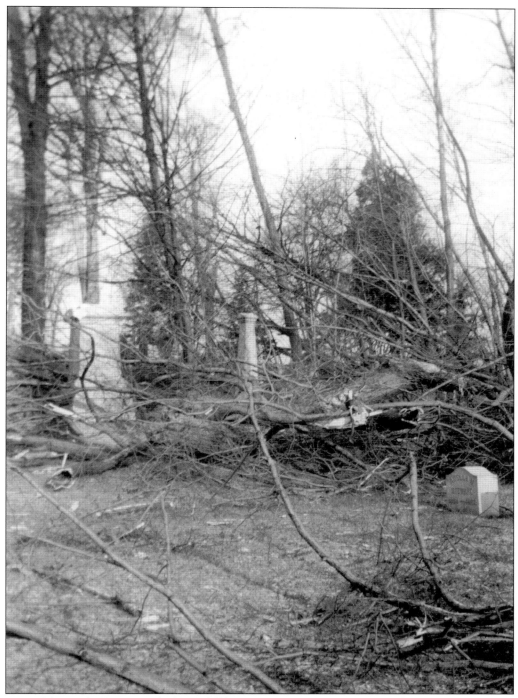

Powerful winds rearranged these hollow trees in a 1950 storm. (Courtesy Fort Hill Cemetery Association.)

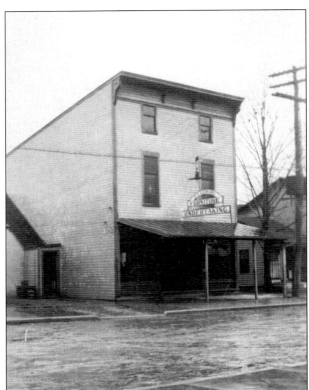

The year 1918 will be a busy one for the C.F. Leonard Furniture and Undertaking establishment. (Courtesy Community Preservation Committee.)

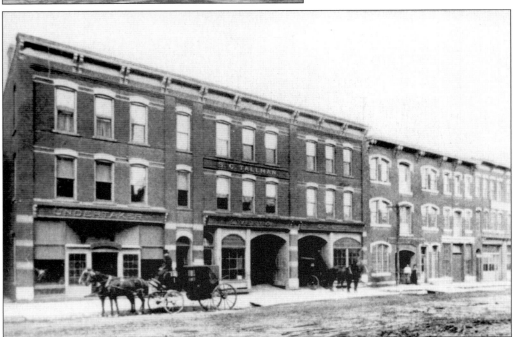

The S.C. Tallman Undertaking and Livery establishment was once at 25 Dill Street, which is now the site of the *Citizen* newspaper offices. (Courtesy Cayuga County Historian.)

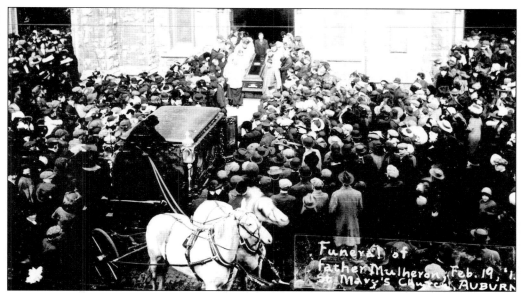

This is a postcard view of the funeral of Father Mulheron on February 19, 1913, at St. Mary's Church in Auburn. Catholics were generally buried in Cold Spring Cemetery, owned by Holy Family Church on North Street, and later in St. Joseph's Cemetery. Even though Father Mulheron was not interred in Fort Hill, this image is typical of the type of funeral of the day. The following month, Harriet Tubman was carried to Fort Hill in just such a hearse, as was Rev. William Hubbard in January. Horse-drawn hearses were in vogue until motorcars replaced them in the 1920s. (Courtesy Lou and Myrtle Chomyk.)

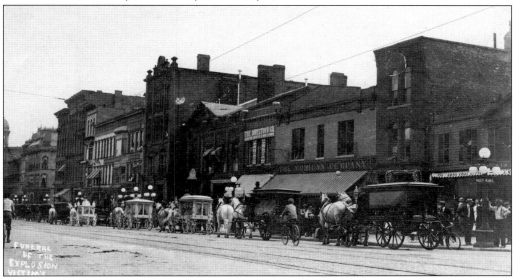

This is a postcard view of the funeral procession of the Cheche family in 1912. The Cheches' house exploded one morning when a cache of fireworks stored up for the upcoming Independence Day celebration accidentally ignited. Several members of the family were killed in the explosion. The Cheches were buried in St. Joseph's Cemetery. Processions of multiple hearses such as this were common in Fort Hill during the Spanish influenza epidemic of 1918. (Courtesy Lou and Myrtle Chomyk.)

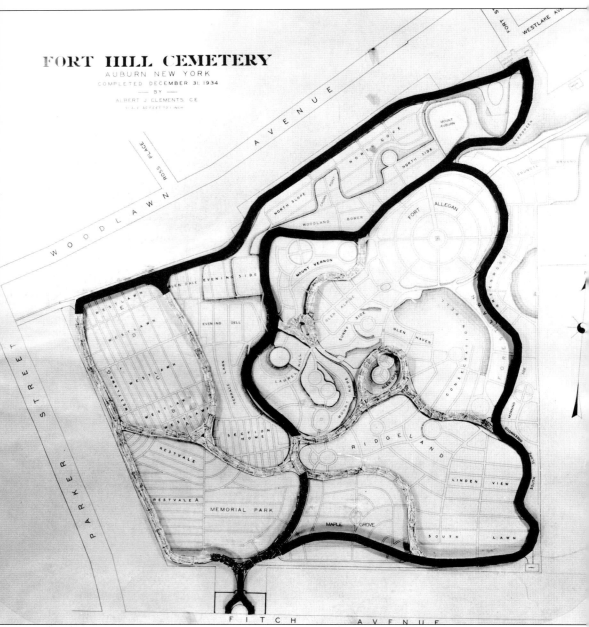

This map shows Fort Hill Cemetery as it appeared in 1934. (Courtesy Fort Hill Cemetery Association.)

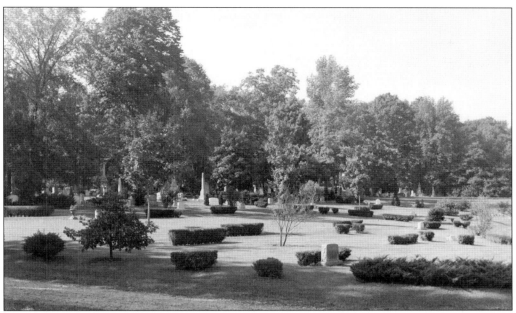

This c. 1951 image captures the period of transition in the cemetery. The east perimeter of the old section with its array of large, ornate monuments and random pattern of plantings are beginning to surrender to a more modern look. The shrubs are spaced and manicured, and the stones are uniform in size and shape. (Courtesy Fort Hill Cemetery Association.)

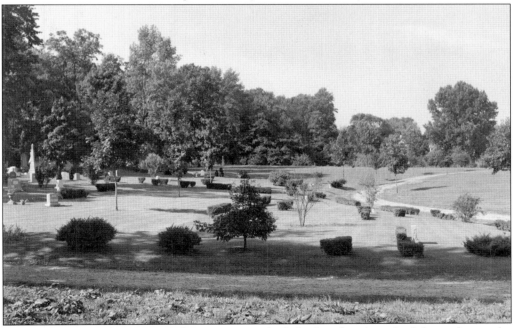

Unlike the original section of the cemetery, which had to be cleared of dense forest, the new section to the east had to be planted with new saplings. This section suggests none of the subjugation of nature as the original grounds did a century before. (Courtesy Fort Hill Cemetery Association.)

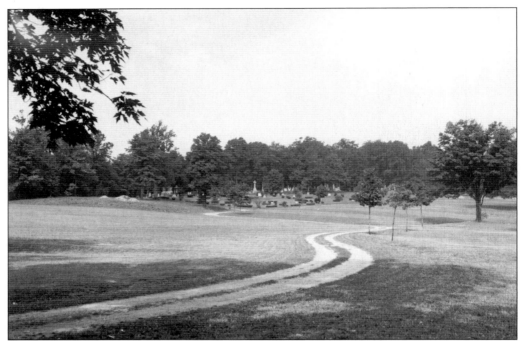

Back to the future: the newest section of the grounds is seen *c.* 1951. This area was formerly a country club golf course. (Courtesy Fort Hill Cemetery Association.)

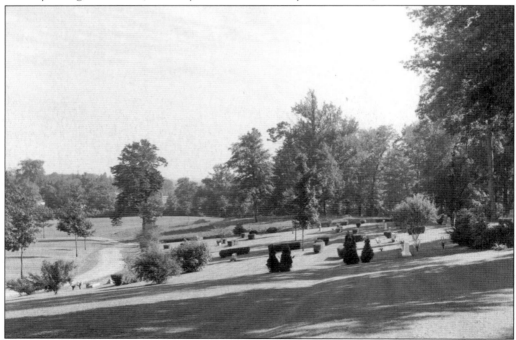

In a view looking southeast across the land toward Fitch Avenue and South Street, this stretch of groomed lawn bears no resemblance to the rugged terrain of the old section. (Courtesy Fort Hill Cemetery Association.)

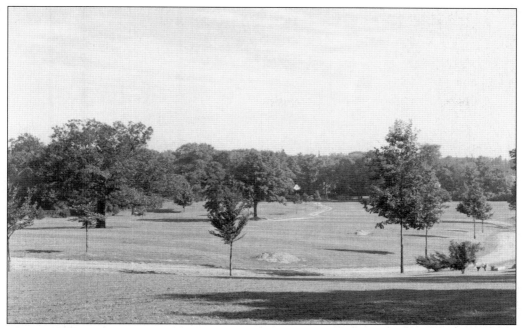

There is little to suggest a cemetery in this 1951 view of the southeast section. It does not look very different 50 years later. It could still be easily regarded as a golf course. (Courtesy Fort Hill Cemetery Association.)

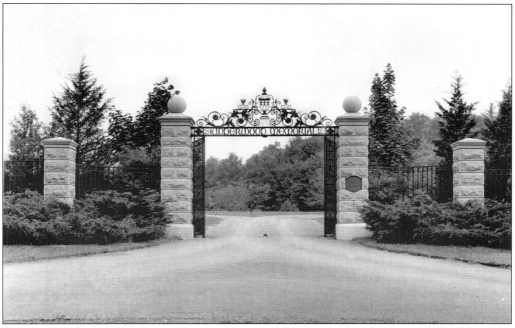

The family of J. Platt Underwood erected the Underwood memorial gate in 1930. The gate is the south entrance to the cemetery from Fitch Avenue. The ornate iron lintel was destroyed in the mid-1960s when a driver of a beer truck took a shortcut through the grounds and tore out the sign above the gates. (Courtesy Fort Hill Cemetery Association.)

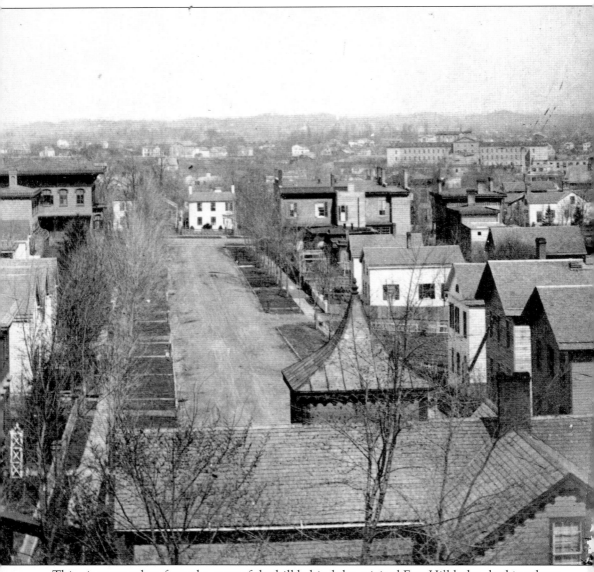

This view was taken from the crest of the hill behind the original Fort Hill lodge, looking down Fort Street to Genesee Street, in the 1860s. The neighborhood around Bostwick Avenue, Woodlawn Avenue, and Westlake Avenue is new, growing, and prosperous. A century later, it will disintegrate into an enclave of slumlord apartments, crime, and drug traffic. By the 1990s, the Homsite Development Corporation will have formed the Fort Hill Square Association to rescue and restore the historic district to reflect the original beauty and tranquility of the area. Auburn Prison is visible in the distance to the right. (Courtesy Seymour Library.)